CLOSE TO HOME

Richard S. Buswell

CLOSE TO HOME

PHOTOGRAPHS

RICHARD S. BUSWELL

FOREWORD by George Miles

INTRODUCTION by Julian Cox

UNIVERSITY OF NEW MEXICO PRESS

Albuquerque

© 2013 by the University of New Mexico Press

Photographs © 2006–2010 by Richard S. Buswell

All rights reserved. Published 2013

Printed in China

18 17 16 15 14 13 1 2 3 4 5 6

Library of Congress Cataloging-in-Publication Data
Buswell, Richard S., 1945–

Close to home : Photographs / Richard S. Buswell ; foreword by George Miles ; introduction by Julian Cox.

 p. cm.

Includes bibliographical references.

ISBN 978-0-8263-5287-3 (cloth : alk. paper) — ISBN 978-0-8263-5289-7 (electronic)

1. Montana—Pictorial works. 2. Frontier and pioneer life—Montana—Pictorial works. 3. Landscapes—Montana—Pictorial works. I. Title.

F732.B85 2013

978.6—dc23

 2012031667

BOOK DESIGN AND TYPE COMPOSITION: Catherine Leonardo

Composed in Adobe Garamond Pro 11/15

Display type is BernhardFashionEFOP Regular

FOREWORD

THE ANXIETY OF INFLUENCE weighs heavily upon contemporary photographers of the American West. All artists, literary or visual, confront the challenge of finding original insight or expression amid the work of their predecessors. Western photographers must navigate between the master-works of pioneer photographers like Carleton E. Watkins and Timothy H. O'Sullivan and their mid-twentieth-century successors, such as Ansel Adams and Edward Weston, on the one hand, and the popular, if often inaccurate, iconography of the western landscape created by Hollywood, televi-sion, and the advertising industry. They face the challenge of creating distinctive work for an audience saturated with images of "the West," past and present. They grapple with popular nostalgia for an imagined past and the extraordinary corpus of outstanding work compiled by those who came before them. To create a portfolio of images that make us look anew at the West requires a mix of courage and patience, persistence and imagination.

For over four decades, Richard Buswell has shown just these qualities as he has turned a youthful hobby into a powerful means for explor-ing the past and present of his Montana homeland. Schooled by his father's fascination with the remnants of Montana's pioneer days, Buswell has explored not the theme-park environments of famous "ghost towns" but the quiet, sober reality of truly abandoned mills, mines, ranches, and homes, places that were probably no more than marginally successful in their heyday and that today are isolated from the currents of everyday life. The places that Buswell visits often exhibit an understated natural beauty, but they are not scenes of majestic grandeur from places like the Yellowstone Valley, whose image was burned into the American consciousness by the work of William Henry Jackson, Frank Jay Haynes, and

their colleagues. Nor does Buswell focus on places of urban exuberance, such as Virginia City, whose street fronts have been re-created and reimagined in countless western movies and television shows. Instead, Buswell has explored the out-of-the-way Montana places in which pioneers from America, Europe, and Asia hoped to find a new, more prosperous life. His places reflect the astonishing energy of pioneers who thought no spot was too remote to be a potential home. They are places once full of human ambition that now lie fallow, in which human intervention on the landscape is being reclaimed by wind and weather, plants and animals. Buswell's photographs capture their remnants for our contemplation. As they provoke us to think about the people and institutions that came before us, they challenge our complacency about the permanence of our contemporary marks upon the land.

Buswell's photographs of such places are neither sentimental evocations of a lost past nor coldly analytic depictions of an archaeological site. While his photographs remind us of what once was and now is gone, they also compel us to focus on the beauty of what survives. A photographer since his youth, Buswell has developed an eye for composition, for framing what he wants us to see, which draws us toward the tangible qualities of the objects he photographs. His photographs convey their heft, texture, and form. We recognize them as remnants, relics, as it were, of a bygone era, but it is their immediate, current presence—not their origin—upon which we focus: the corroded surface of a discarded stove top; the frayed cords of a worn-out tire; the shattered, warped shingles of a failing roof; rusty nailheads in a rough-hewn log wall; crumbling sod atop a collapsing dugout; the tattered edges of a worn burlap window curtain; the splay of leaves through the taught wire frame of

a slumping lean-to; the layers of grime that have accumulated on scattered playing cards. These and many other surfaces are palpable in Buswell's photographs. We can almost feel them in our hands, on our fingers. The objects may be from a long time ago, but now, through Buswell's images, they are here with us, and we, in a psychological if not physical sense, are able to move back in time to be with them when they were fresh and new.

Buswell's photographs also explore timeless qualities of form that allow us to span the chronological gap that separates us from Montana's pioneer population. He highlights the formal beauty that inheres in his rediscovered remnants. The graceful arc of the tines of a potato shovel, the complex curves sculpted in the wooden hooves of carousel horses, the elegant simplicity of blown-glass elixir bottles, the intricate jigsaw-puzzle pattern of sutures in an animal's skull, the symmetrical circles of coffee pot lids framed by the outlines of a rectangular storage box all pull our eye and mind out of time to see and think about what endures, about the persistent expression of shapes and forms that enchant and enthrall across generations. We find an intimate connection to the people who made and used those things.

In the two decades since his work was initially exhibited and published, Richard Buswell's photographs may be said to have grown more abstract. He has moved from studies of buildings on the land and depictions of interior rooms to more tightly framed compositions of smaller pieces of the past. But his early work fully reflects the interest in shape, form, and light that become especially prominent in his more recent work. At the same time, Buswell's newer images remain closely linked to the concrete qualities of a particular time, place, and object. Whereas Edward Weston seemed to delight in making us wonder whether we were looking at a nude figure, a seashell, or a pepper, Buswell's images—even at their most abstract—seem to exult in revealing to us the qualities of a particular thing or place. His work bridges Montana's past and present by making historical artifacts a part of contemporary contemplation and conversation.

There is a whimsy in Buswell's work that reflects his approach to Montana's history. He is respectful without being reverent, amused by what he finds without being patronizing. He appreciates the accomplishments of early pioneers even as his photographs document how frail those achievements are in the face of natural forces. It is, perhaps, an extension of his training as a medical doctor that he seems to understand the ephemeral quality of human "success" measured across history. And yes, his images, which powerfully convey the beauty he has found in Montana's historical landscape, testify to photography's ability to embody time, to capture in a momentary exposure the complexity of history. They resist the tide of time by making it apparent to us. They remind us of our roots and humanely warn us of our likely fate. They are a wonderful addition to the visual record of the American West.

—George Miles
William Robertson Coe Curator
Yale Collection of Western Americana
Beinecke Rare Book & Manuscript Library

INTRODUCTION

PHOTOGRAPHY IS A NATURALLY elegiac medium, eulogizing what is past by preserving a trace of it. Photographs are permanent imprints of a time and a place, of the once-was. They are the truths of unexplained remainders, and they convey time both thievishly and generously. But they can also be as malleable and as symbolic as our own ever-shifting perceptions. Richard Buswell's photographs show the effects of change but not necessarily the cause. By turns plucking an instant from the flow of instants and prolonging the duration of the visible well beyond the momentary, they describe and intimate timelessness. They beget as much as they tell stories.

For over four decades, Richard Buswell has trained his camera on the landscape of Montana, with its abandoned and overgrown homesteads and majestic, never-ending skies. An avid photographic collector of material culture, Buswell has accumulated a sophisticated visual document that amply suggests the historical complexion of his native state. The pictures constitute a rich, nuanced archive that will stand for the ages. This is one outcome of the photographer's long view, but there are more immediate gains to relish from this project. For one thing, Buswell produces photographs that are beautiful, choice objects. They are the work of a consummate technician who has resisted the breakneck evolution of digital technology and continues to favor traditional photographic materials. Fine-grained, 35 mm roll film and lustrous fiber-based gelatin silver paper provide the latitude that suits his vision.

In the recent work assembled in this volume, Buswell revels in graphic adventures, seeking out one-of-a-kind forms in abandoned objects and in nature. His subjects are much more than scattered remains implied by the word *debris*, and while they allude to the completion of a process, the word *remnant* barely contains them. There is a hint of the miraculous about them. Repeatedly the photograph's bounding rectangle formulates space by framing it, simultaneously lavishing the imagination with a sense of vision beyond what is shown. Buswell's photographs create rich meaning and portent through severances. When we study each picture intently, we realize that the subject is not merely a fragment of an object, building, or place but a complex visual shard that embodies the photographer's concentrated thoughts and emotions. A lifetime of learning, observation, and intuition is in each picture:

> In the composition, the artist does exactly what every eye must do with life, fix the particular with the universality of his own personality—Taught by the largeness of his imagination to feel every form which he sees moving within himself, he must prove the truth of this by expression. (William Carlos Williams, *Spring and All*, 1923)

In *Spring and All*, William Carlos Williams zealously promotes the supremacy of the imagination. Something akin reigns when Richard Buswell, the doctor and fourth generation Montanan, sets his tripod, adjusts his aperture, and perfects his framing to savor the majesty of cast-off, common things. Such gifts, we come to understand, may be found in the grass beneath our feet, close to home. We just need some help getting there.

—Julian Cox
Founding Curator of Photography and
Chief Curator Fine Arts Museums of San Francisco

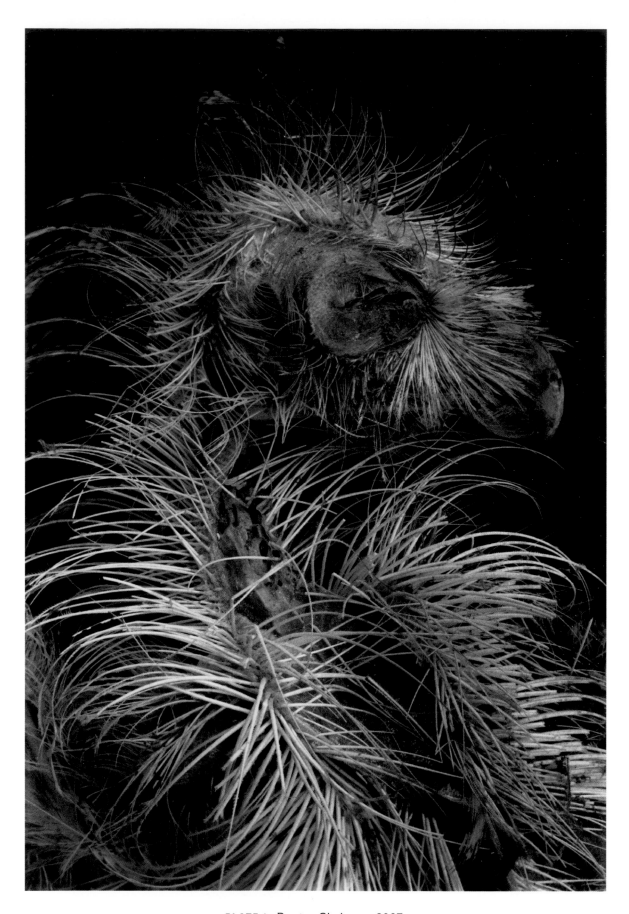

PLATE 1: Raptor Skeleton, 2007

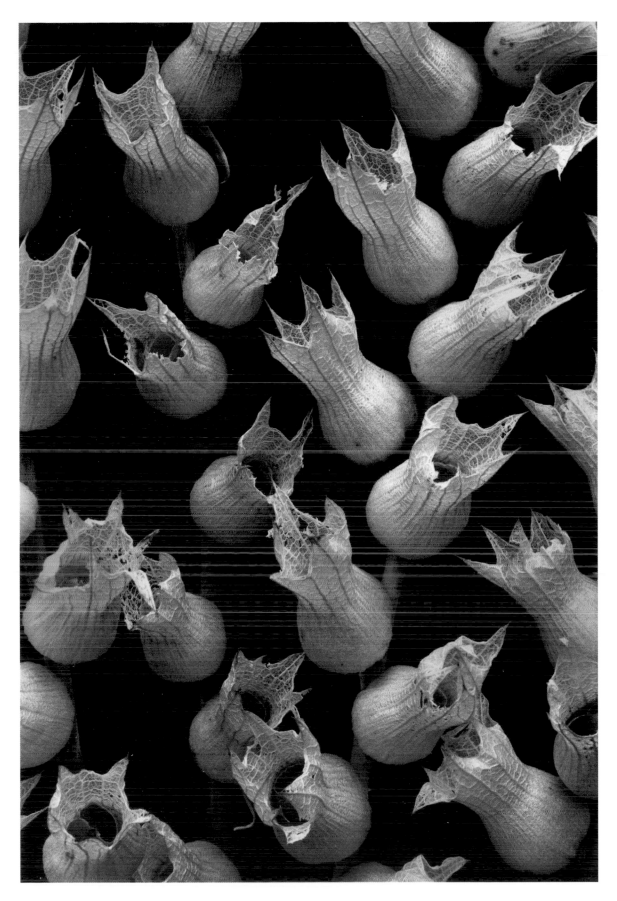

PLATE 2: Seed Pods in a Corral, 2008

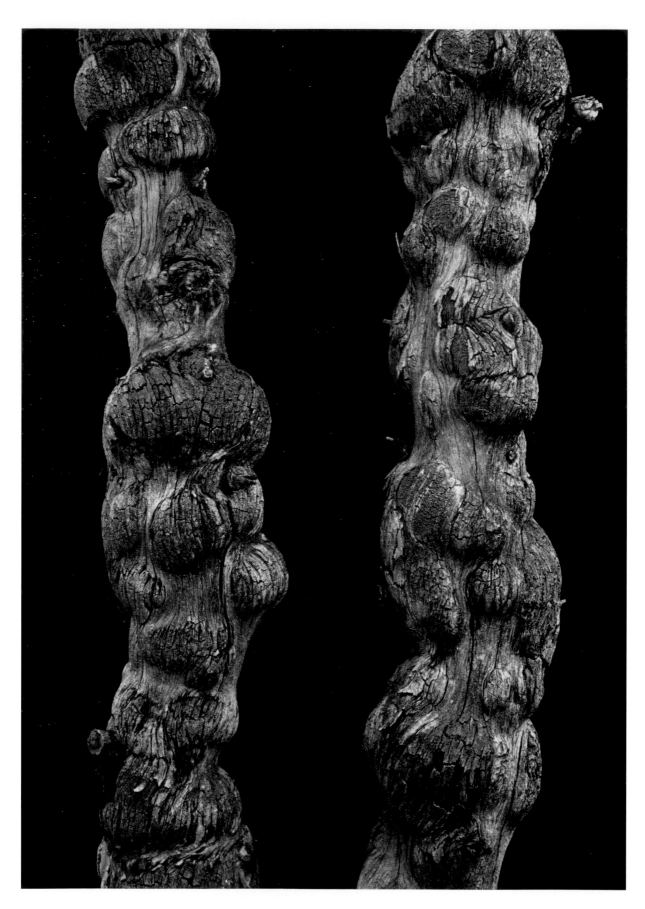

PLATE 3: Two Fence Posts, 2009

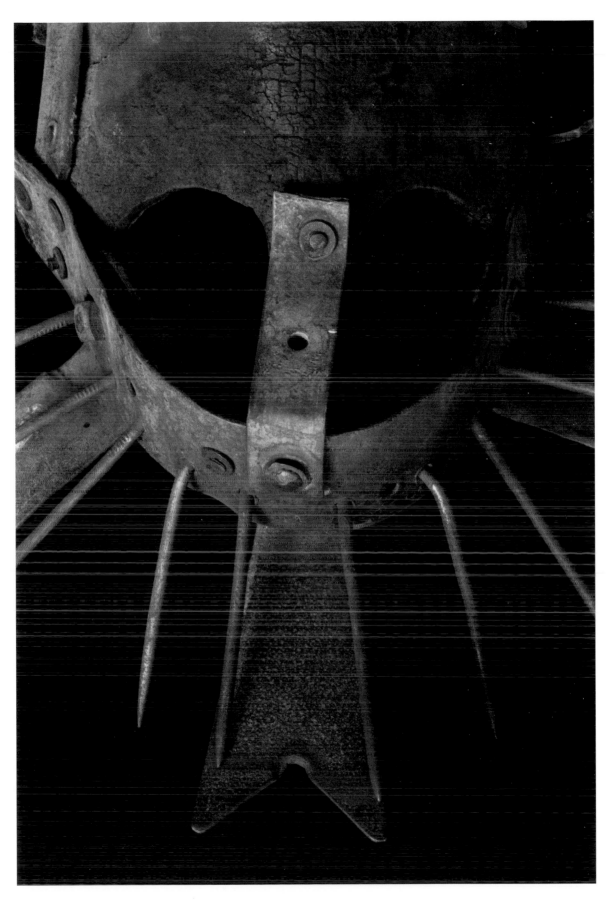

PLATE 4: Weaning Mask, 2009

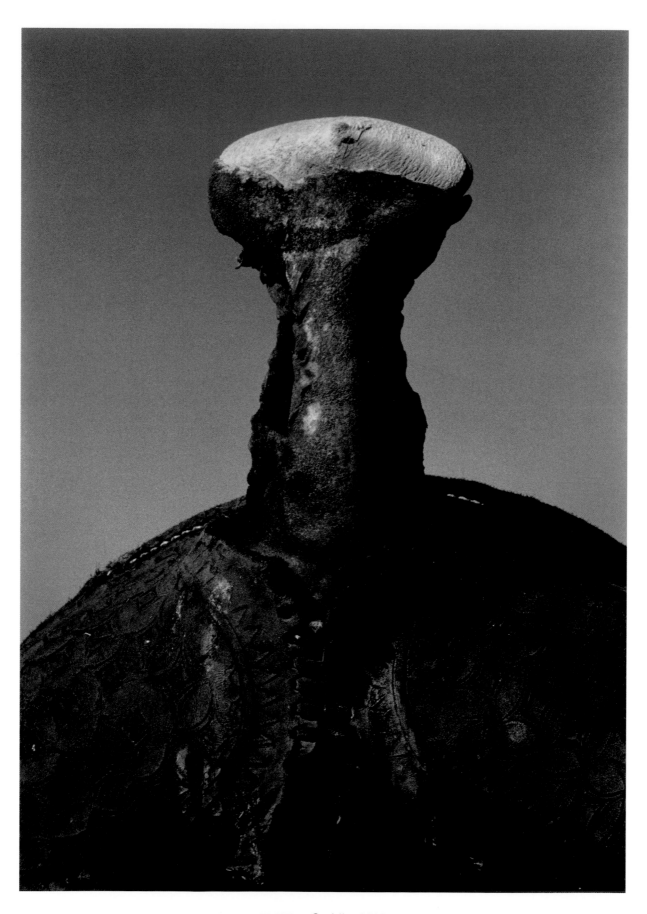

PLATE 5: Saddle, 2006

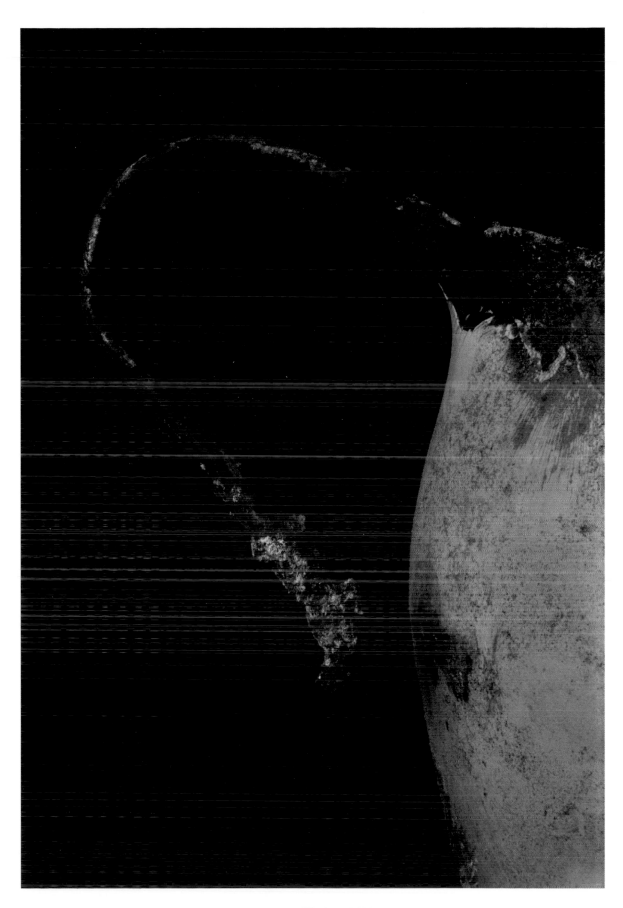

PLATE 6: Pitcher, 2010

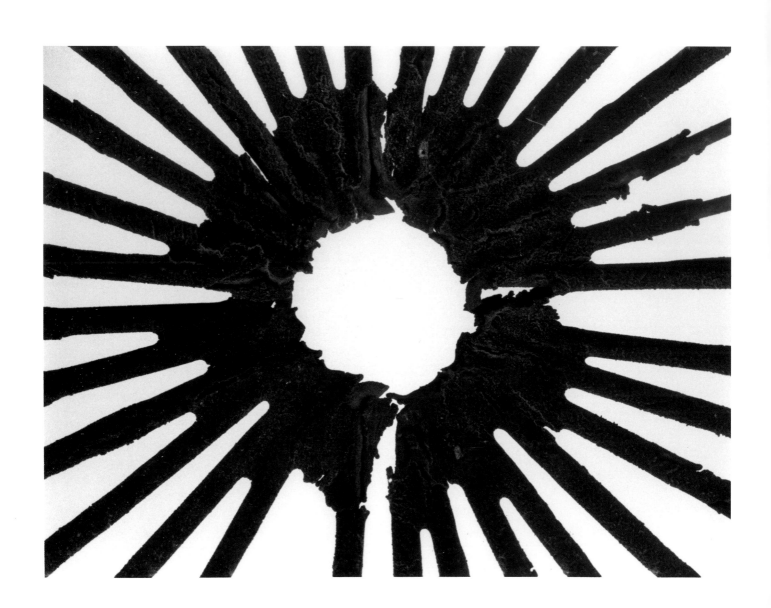

PLATE 7: Potato Bucket, 2007

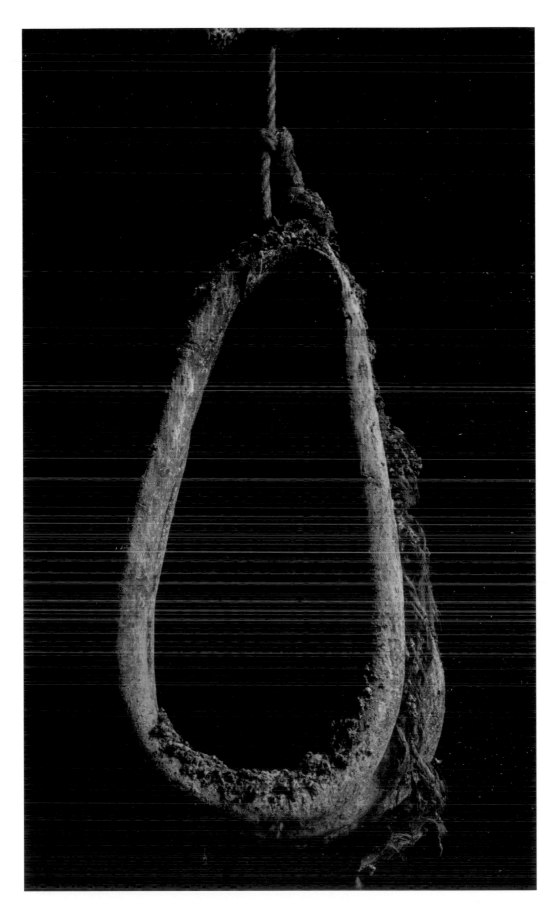

PLATE 8: Horse Collar Swing, 2007

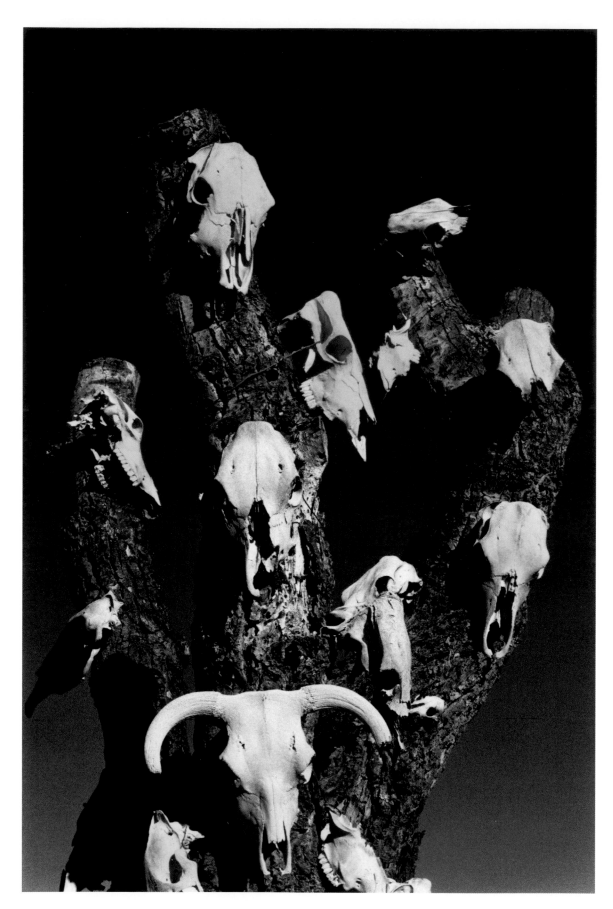

PLATE 9: Skull Tree, 2010

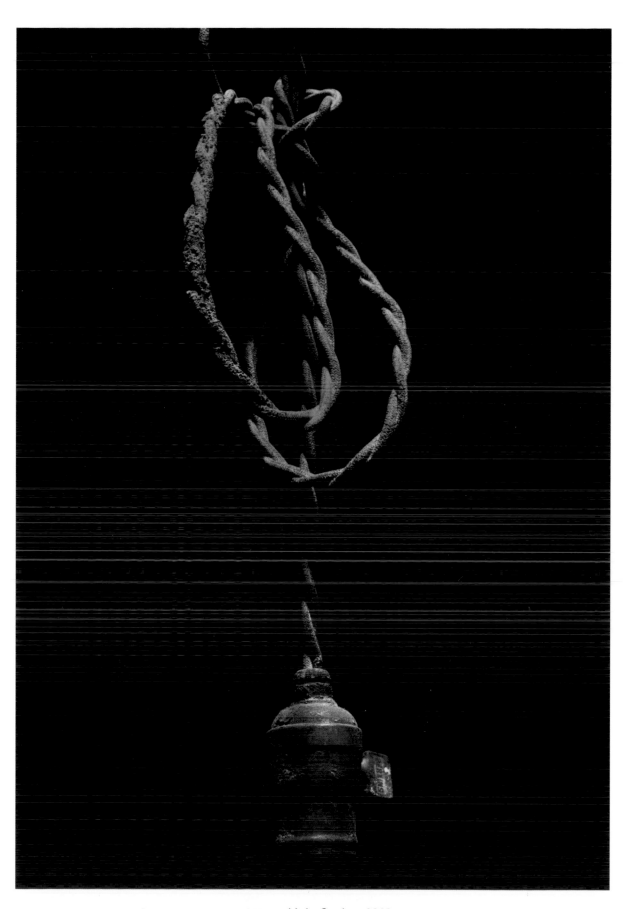

PLATE 10: Light Socket, 2010

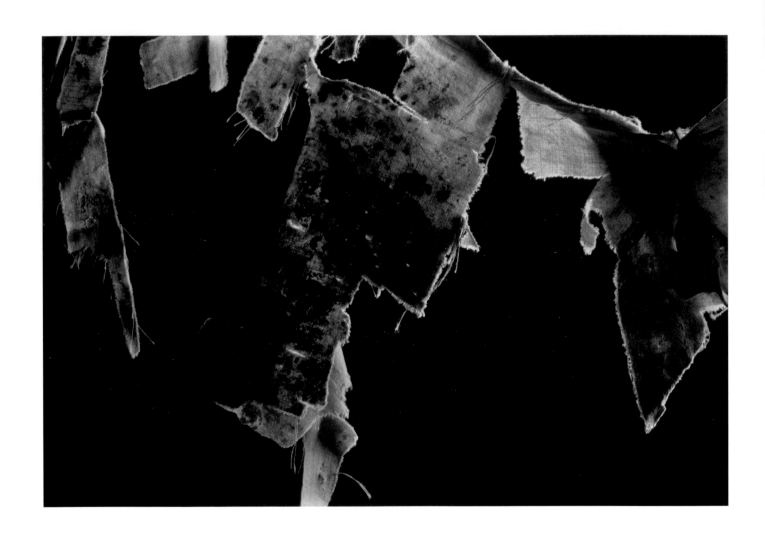

PLATE 11: Window Shade, 2006

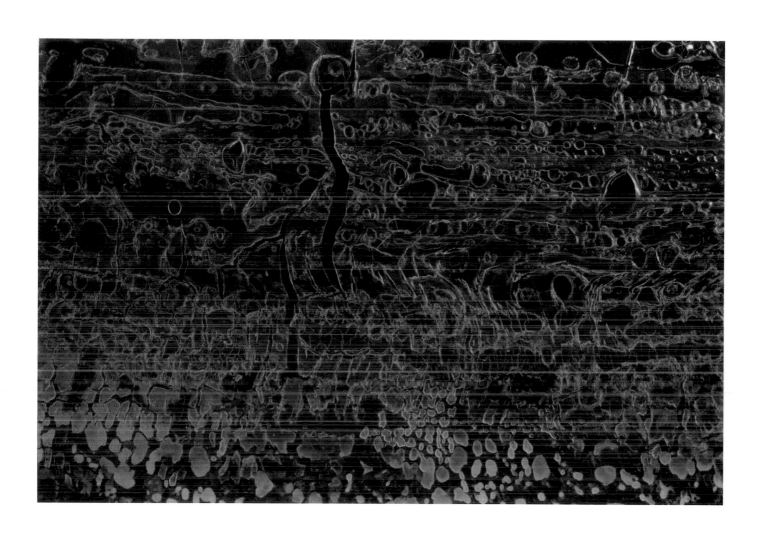

PLATE 12: Fractured Window No. 2, 2008

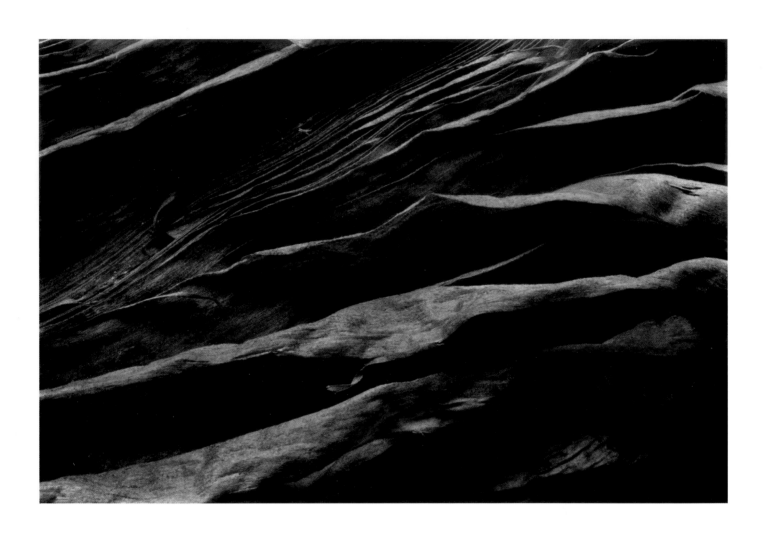

PLATE 13: Chinese Herbs, 2009

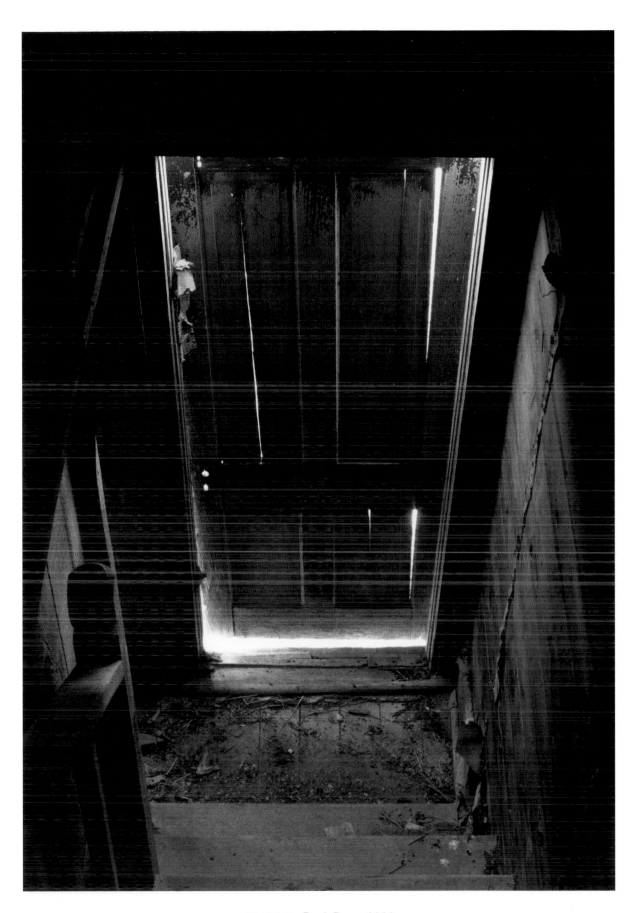

PLATE 14: Back Door, 2009

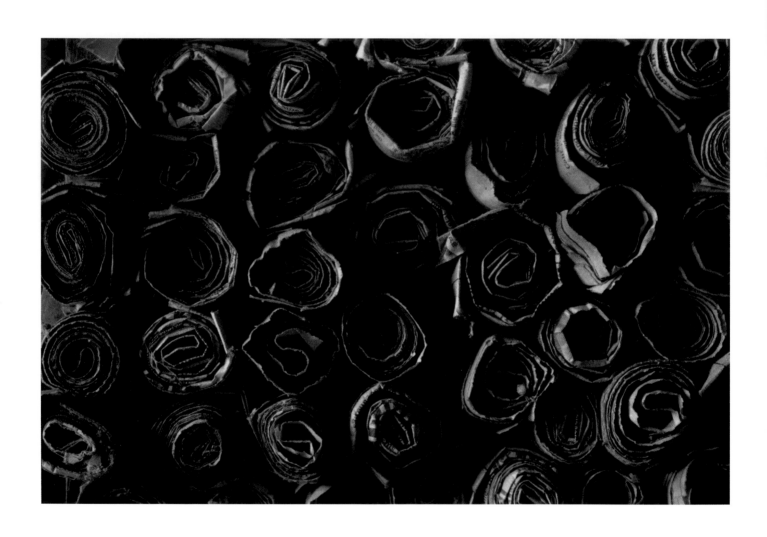

PLATE 15: Rolled Newspapers, 2006

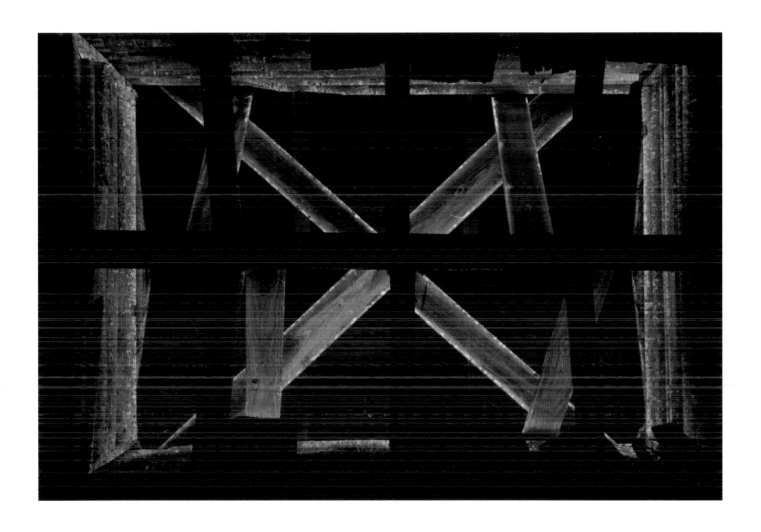

PLATE 16: Barn Ventilator, 2007

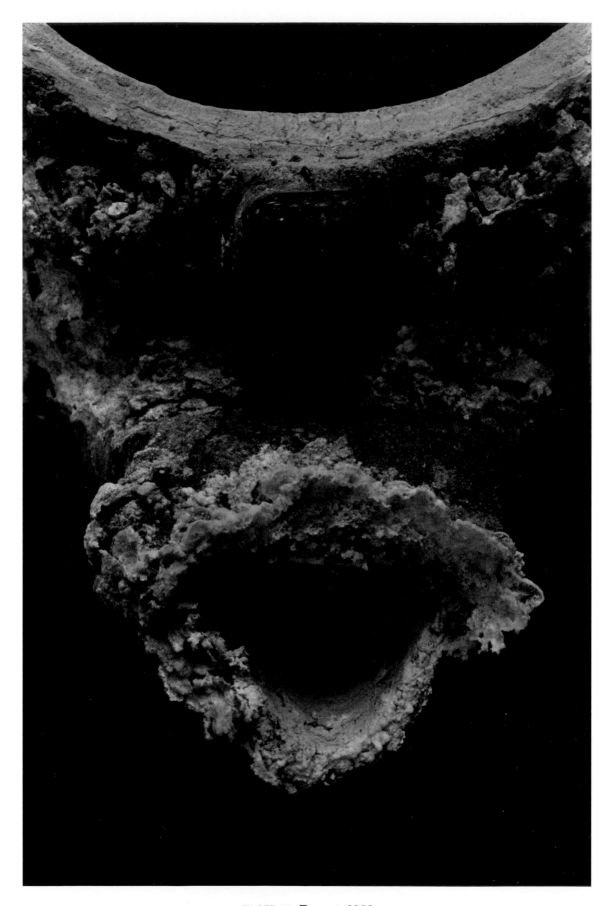

PLATE 17: Teapot, 2008

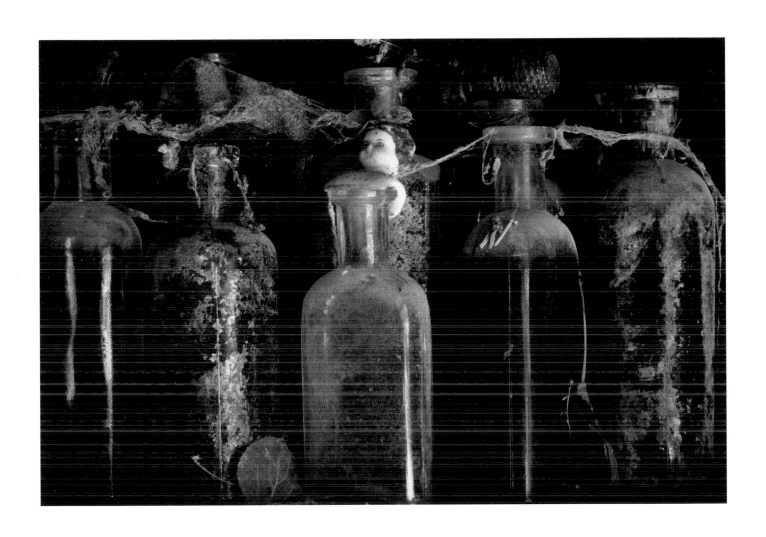

PLATE 18: Elixirs, 2006

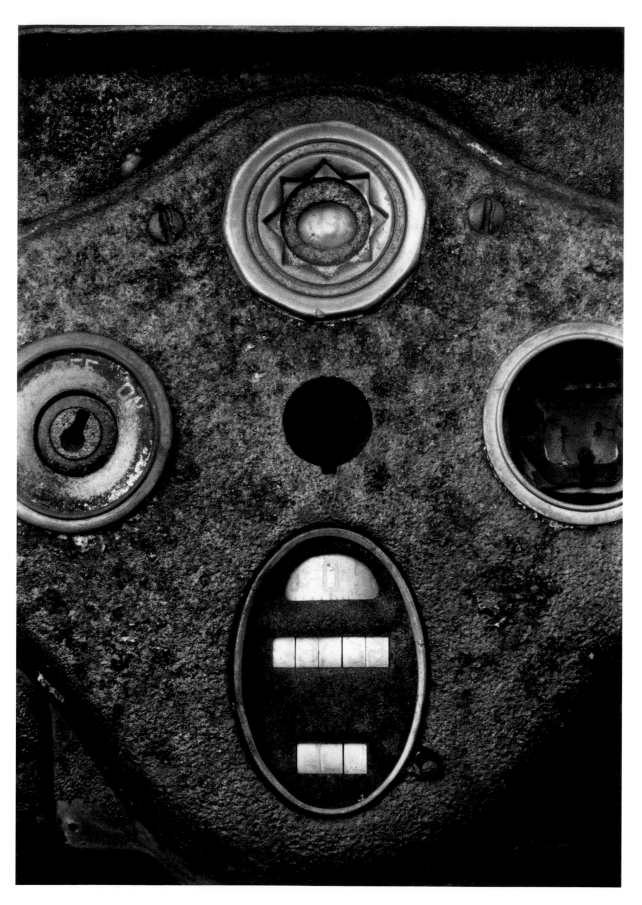

PLATE 19: Dashboard, 2006

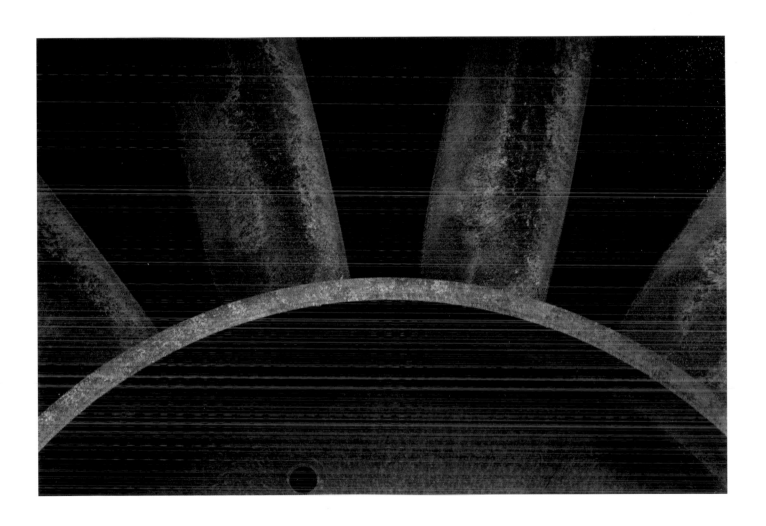

PLATE 20: Hoist Wheel, 2006

PLATE 21: Abacus, 2008

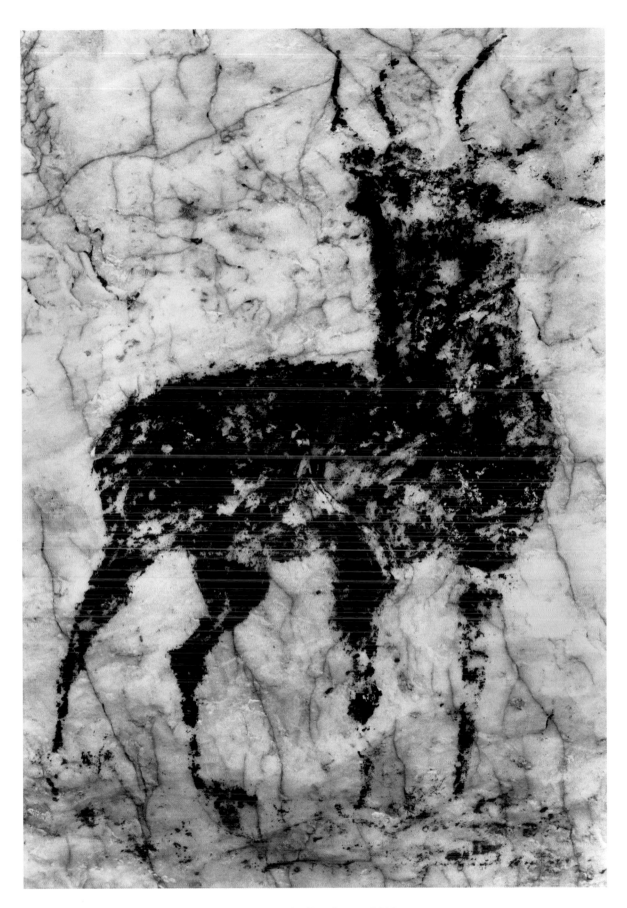

PLATE 22: Indian Grave, 2010

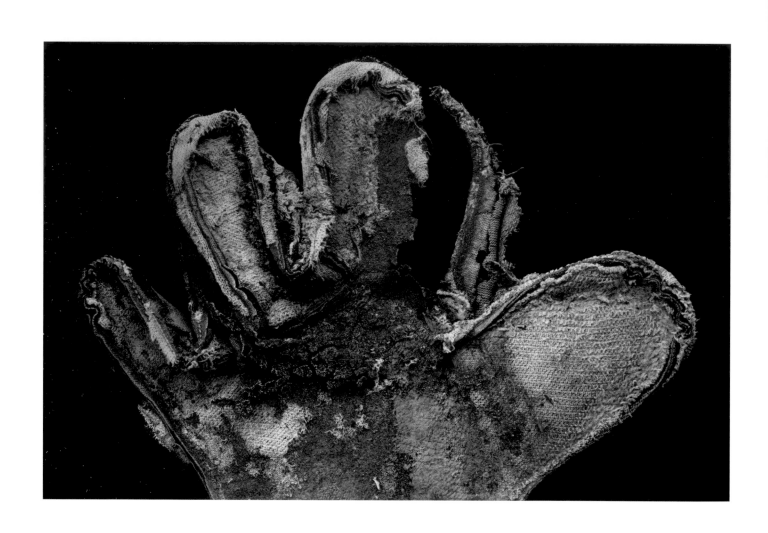

PLATE 23: Miner's Glove, 2010

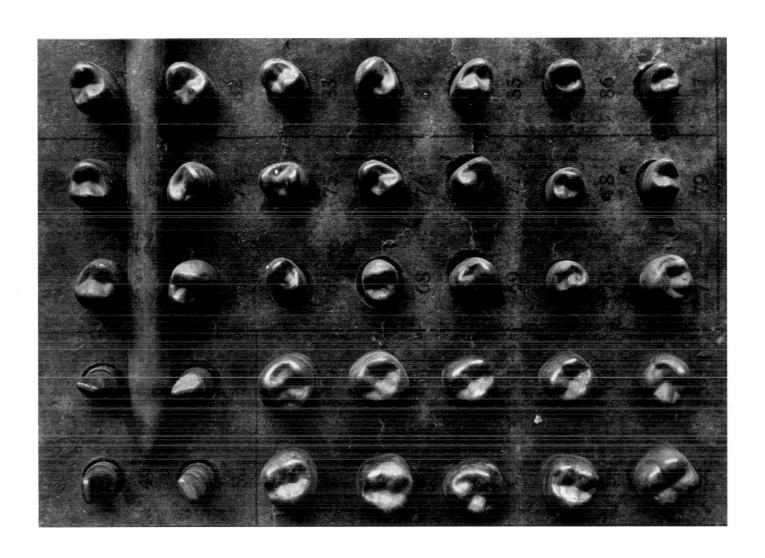

PLATE 24: Dental Crowns, 2009

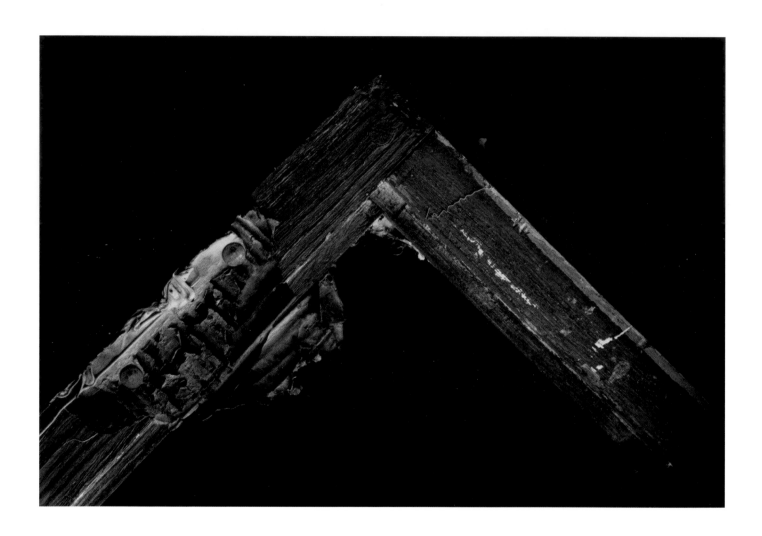

PLATE 25: Window Frame, 2007

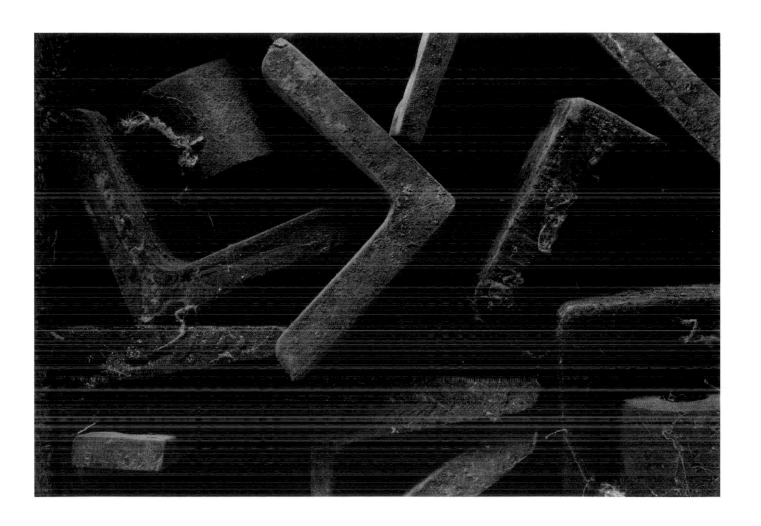

PLATE 26: Scrap Iron, 2007

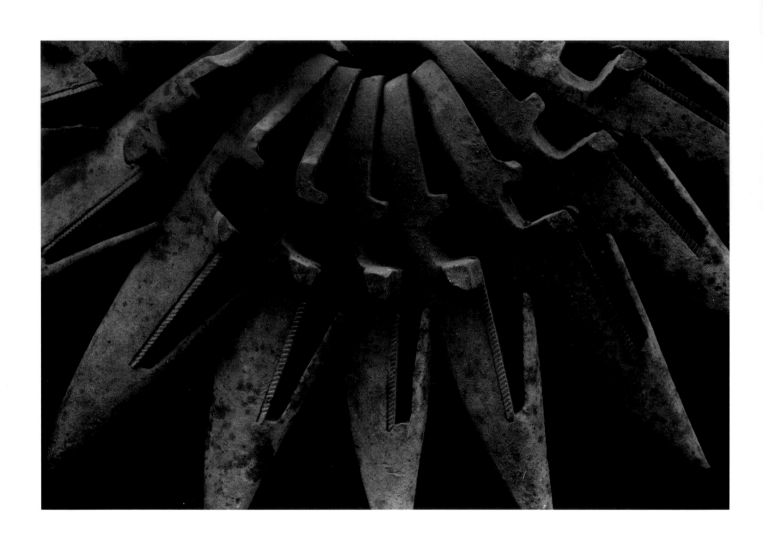

PLATE 27: Sickle Guards, 2007

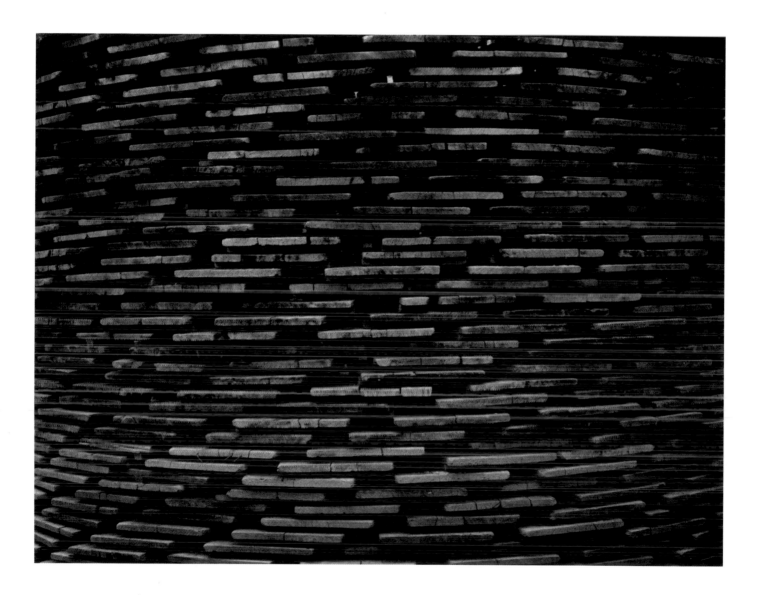

PLATE 28: Stacked Lumber, 2010

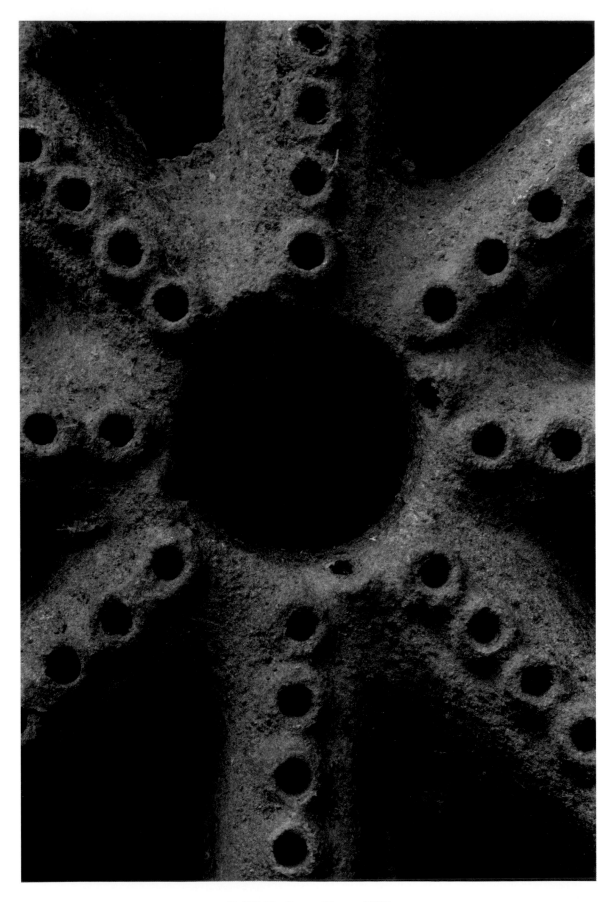

PLATE 29: Camp Stove, 2007

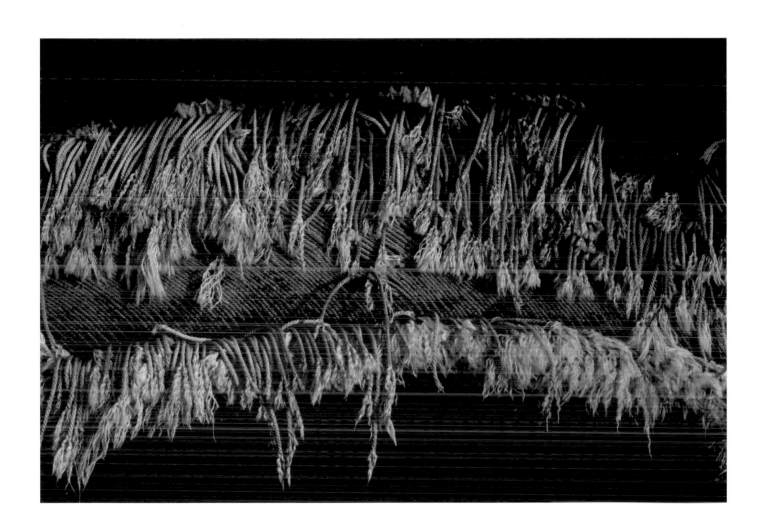

PLATE 30: Tire, 2006

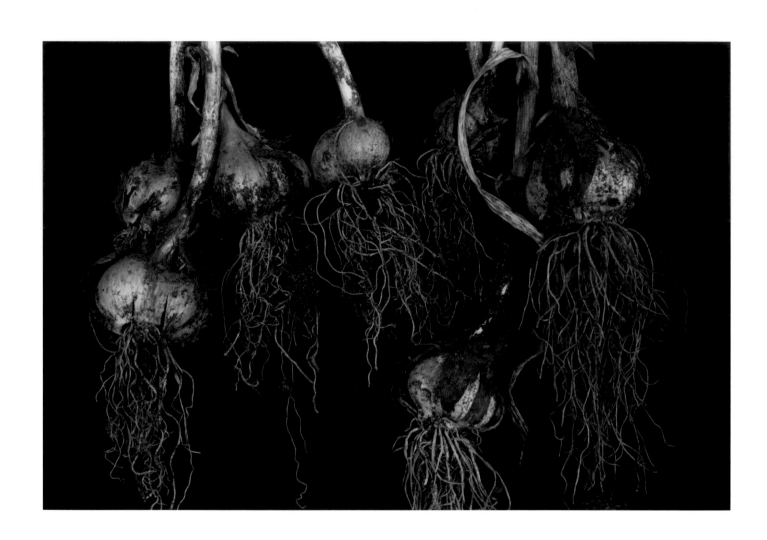

PLATE 31: Abandoned Garlic, 2009

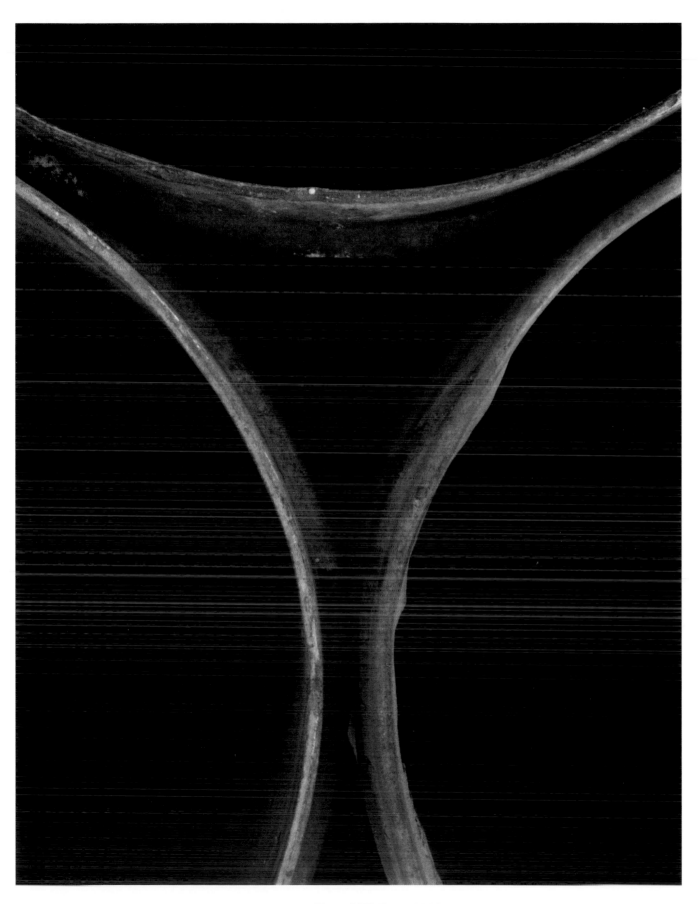

PLATE 32: Three Milk Cans, 2006

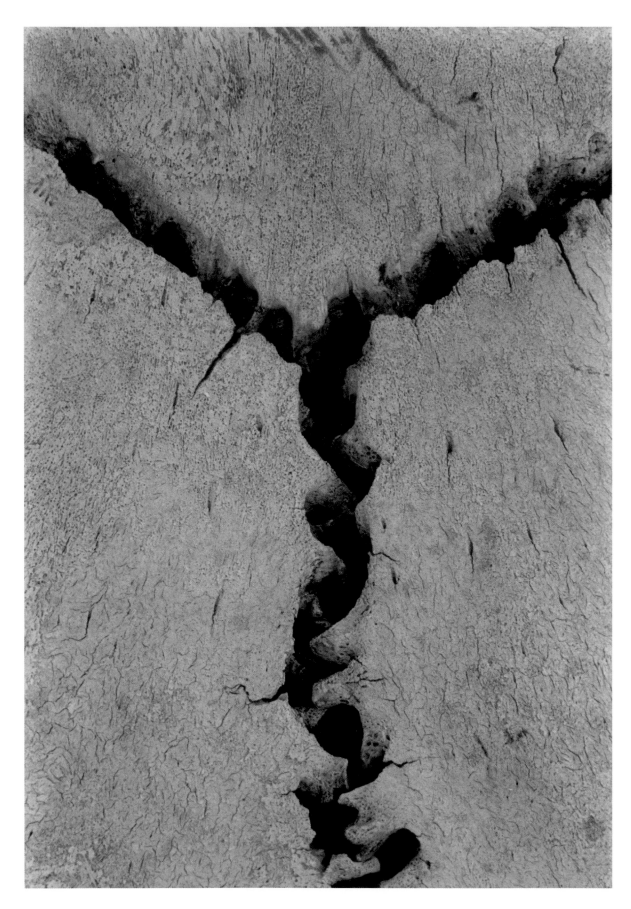

PLATE 33: Skull Sutures, 2007

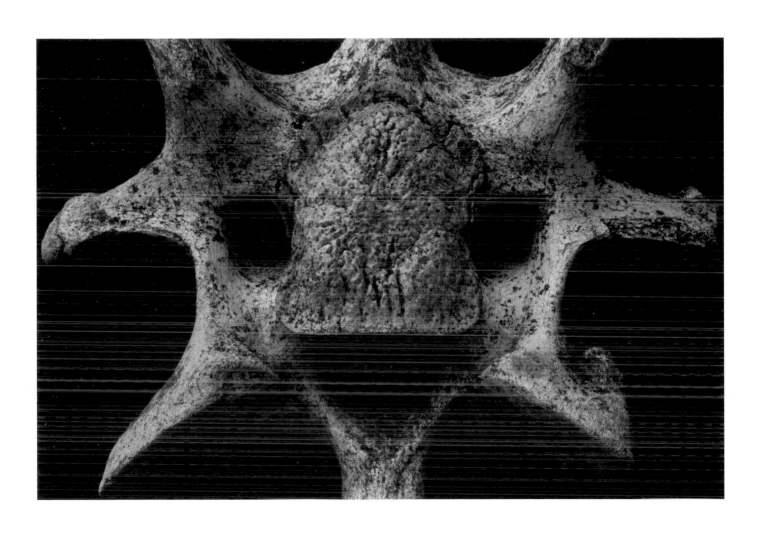

PLATE 34: Bone Series No.1, 2009

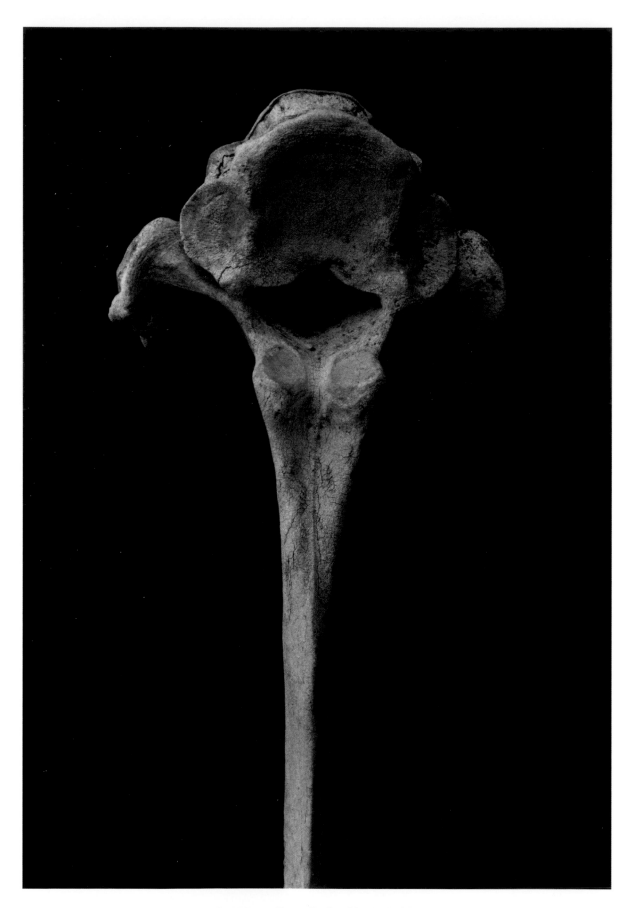

PLATE 35: Bone Series No. 2, 2009

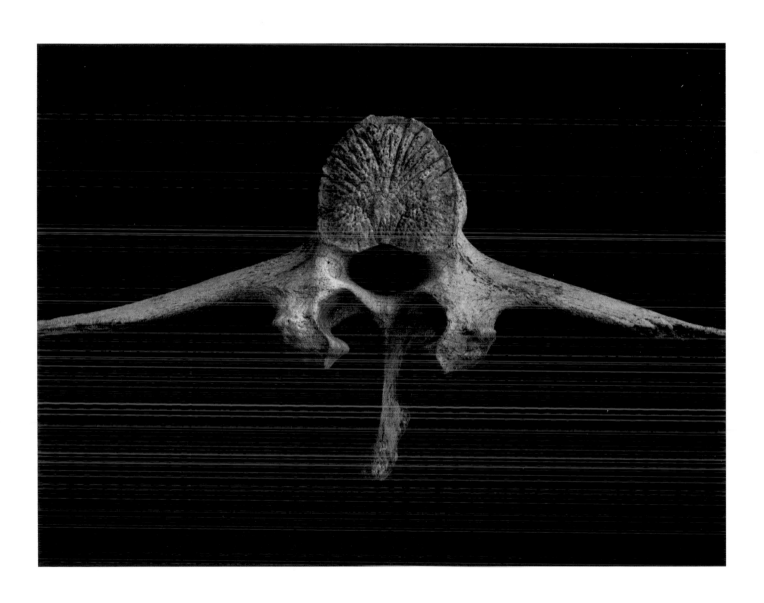

PLATE 36: Bone Series No. 3, 2009

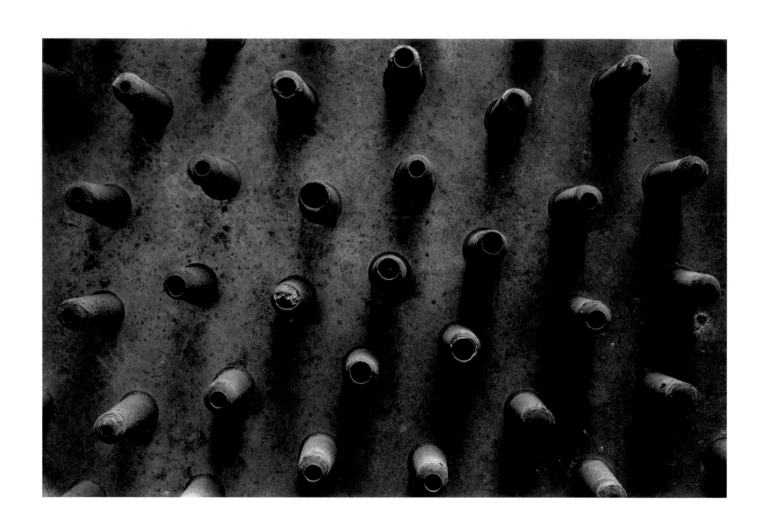

PLATE 37: Gas Lamp, 2009

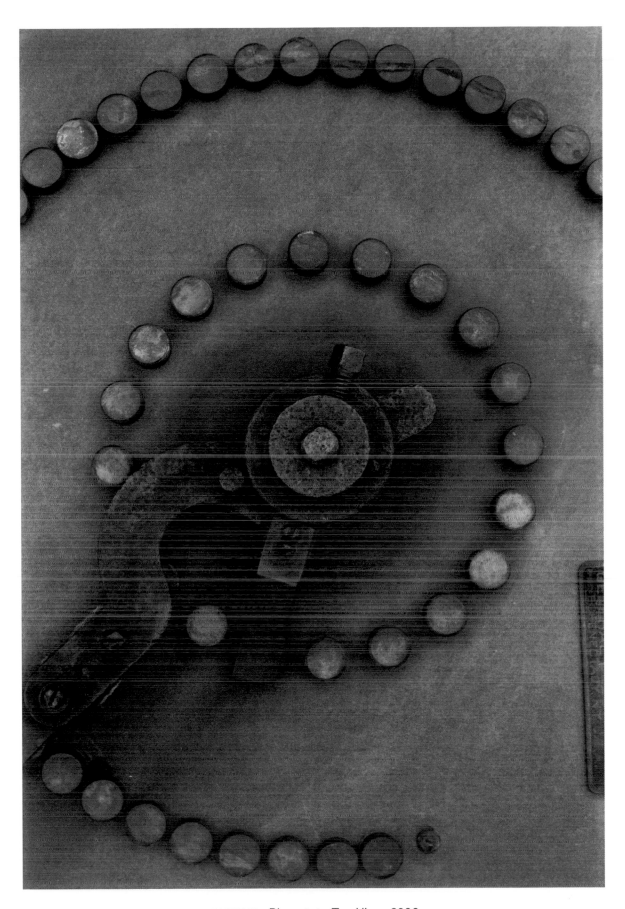

PLATE 38: Rheostat—Top View, 2006

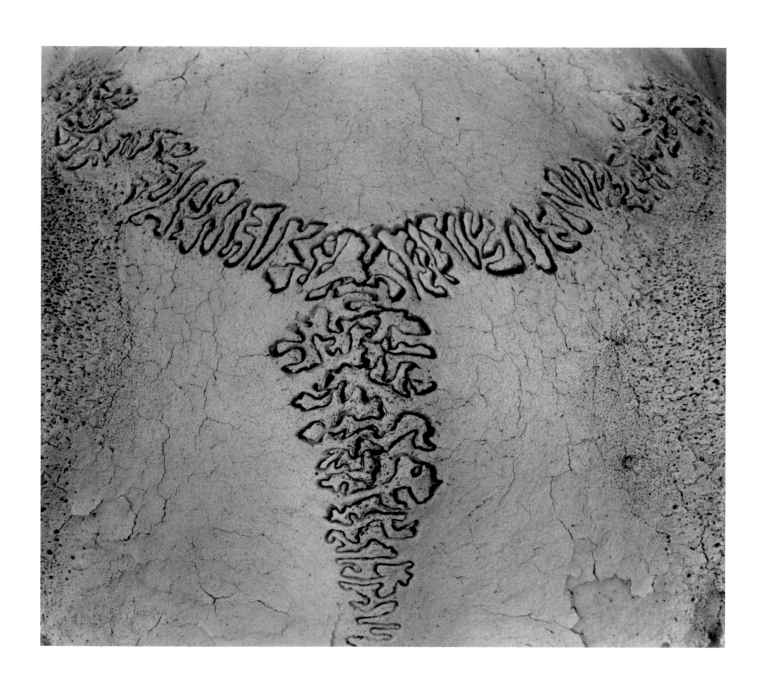

PLATE 39: Coyote Skull, 2010

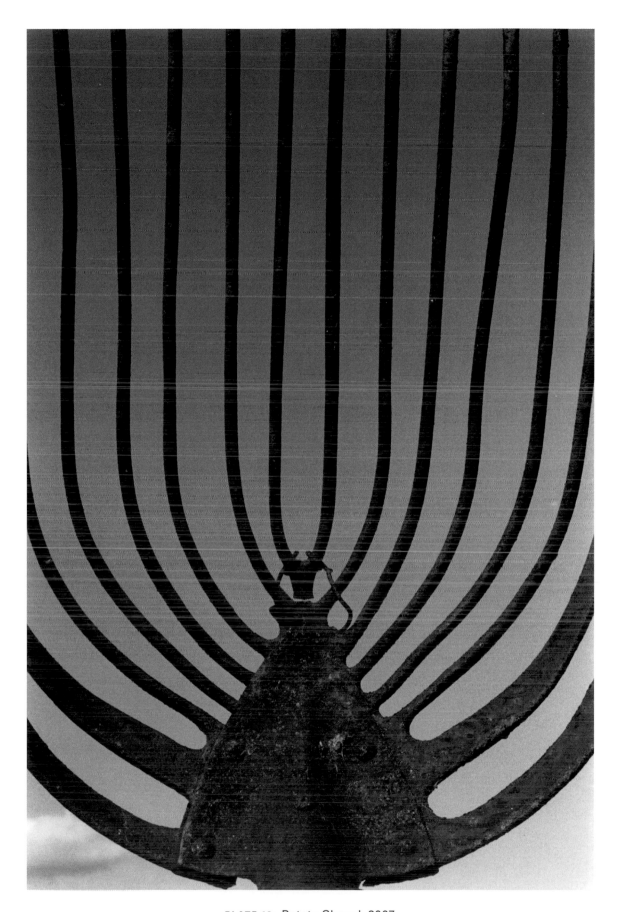

PLATE 40: Potato Shovel, 2007

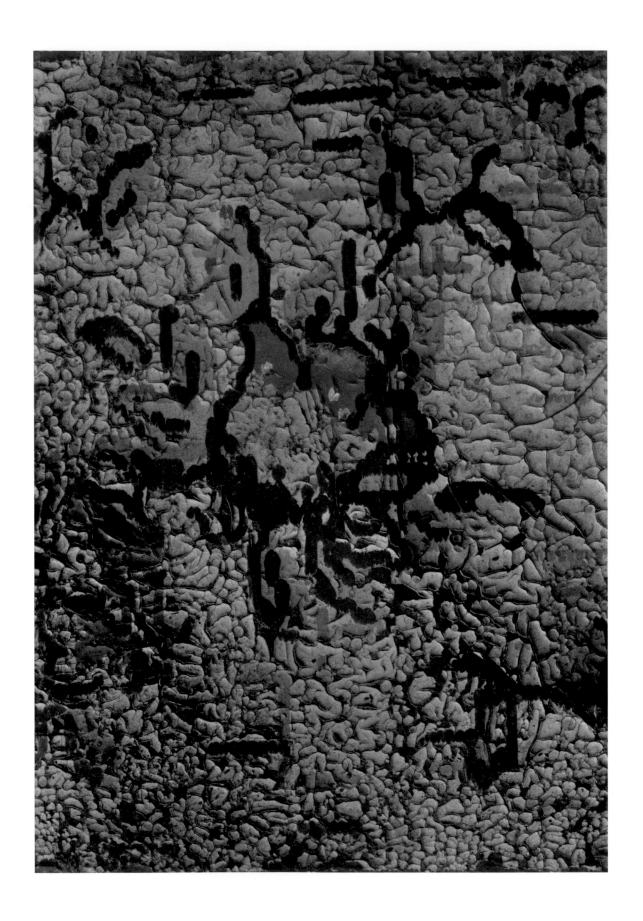

PLATE 41: Door Jamb, 2006

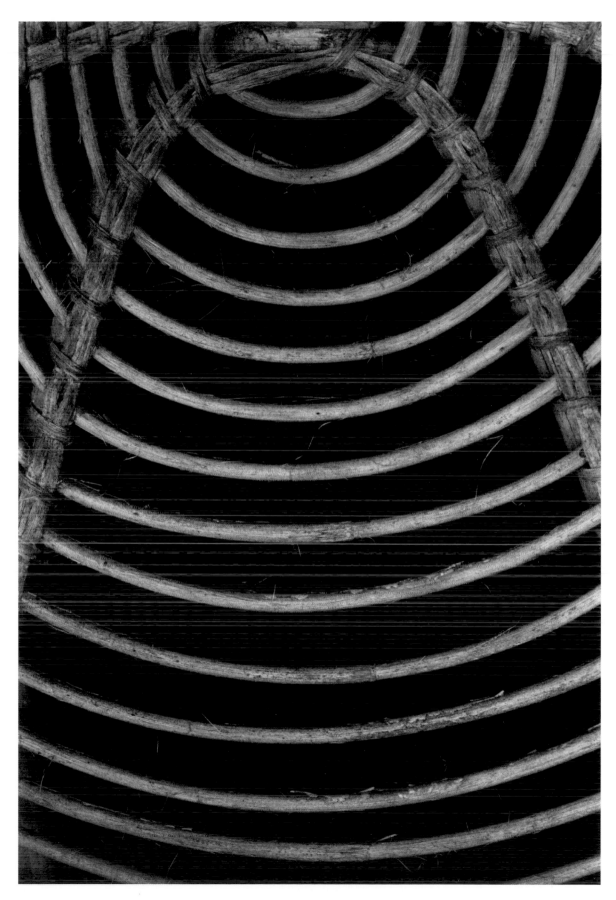

PLATE 42: Wicker Chair, 2009

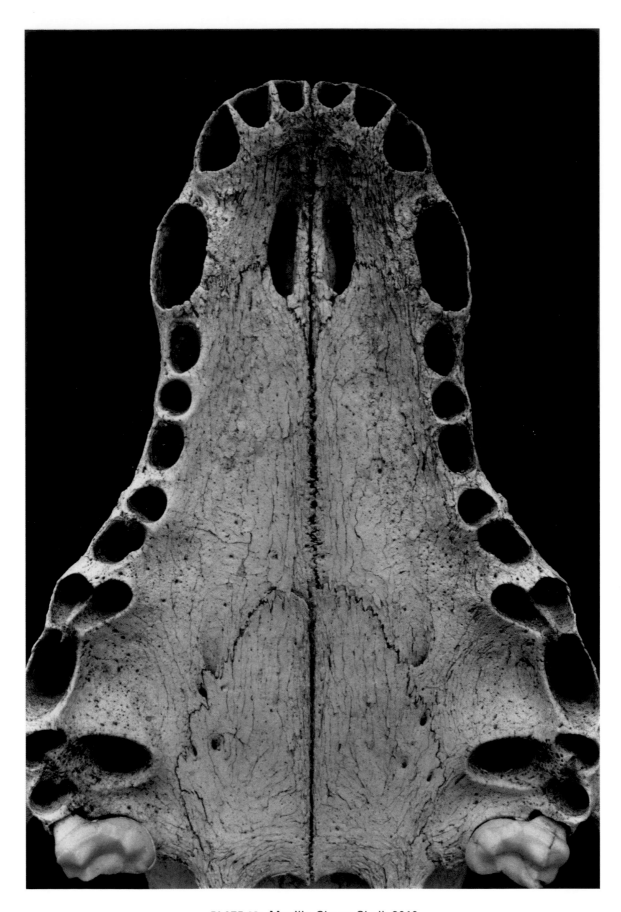

PLATE 43: Maxilla-Sheep Skull, 2010

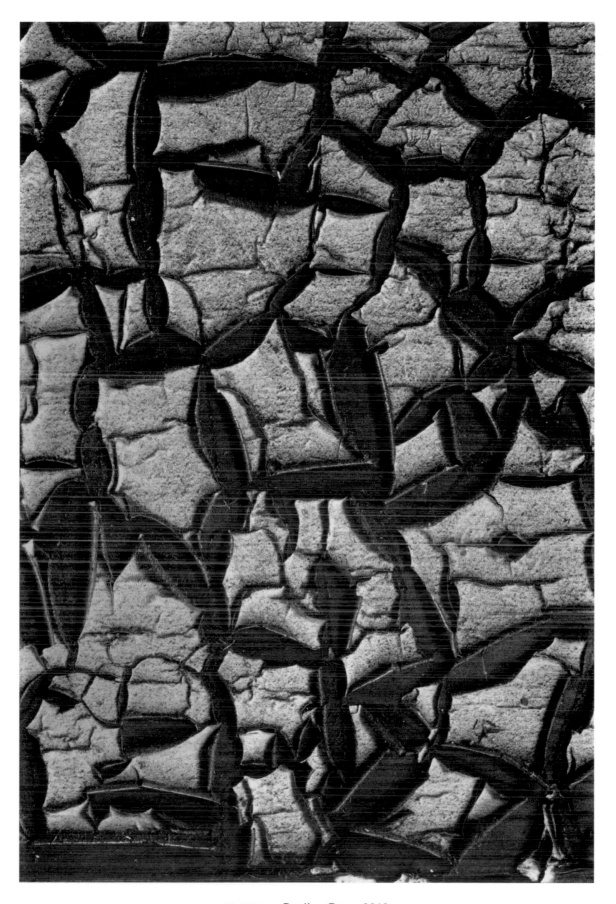

PLATE 44: Peeling Door, 2010

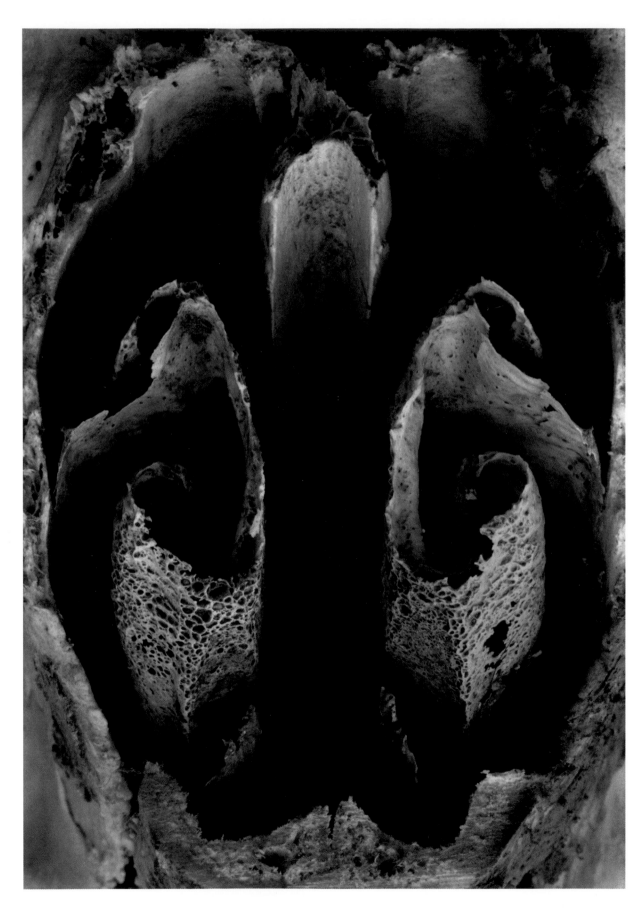

PLATE 45: Nostril Interior—Calf Skull, 2010

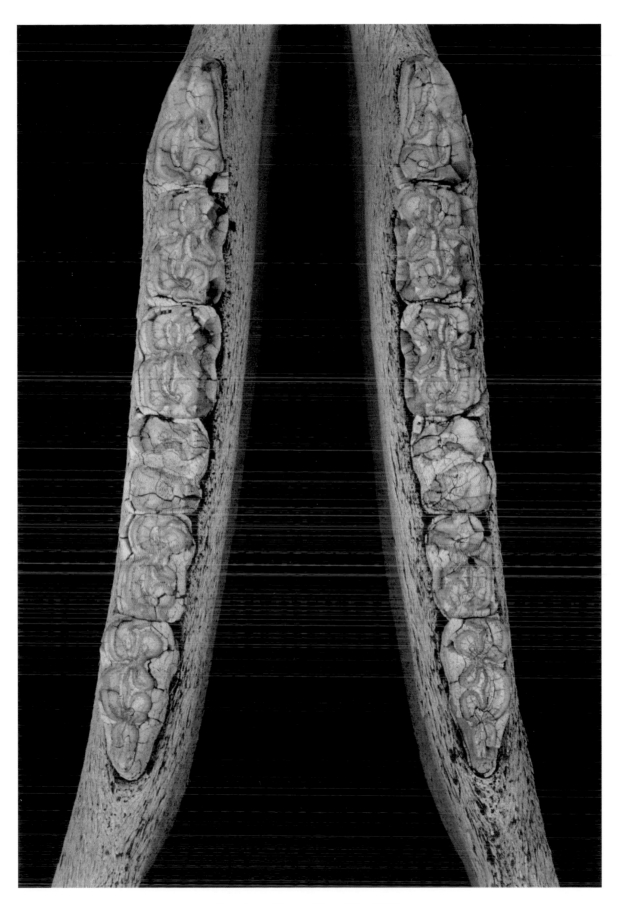

PLATE 46: Horse Mandible, 2008

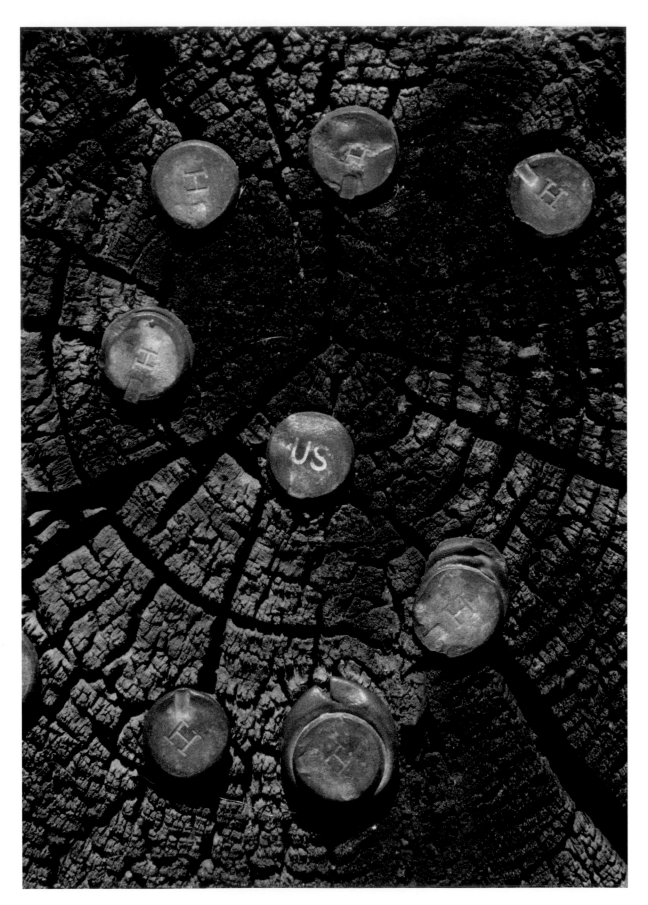

PLATE 47: Shell Casings, 2007

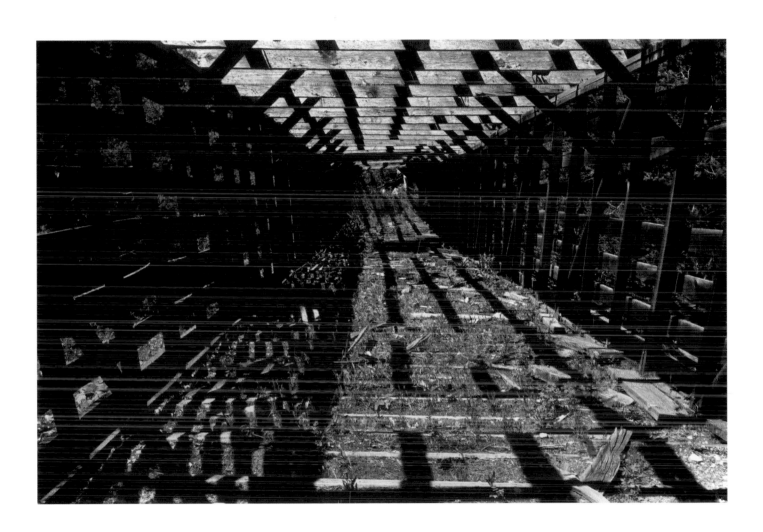

PLATE 48: Ore Chute No. 2, 2009

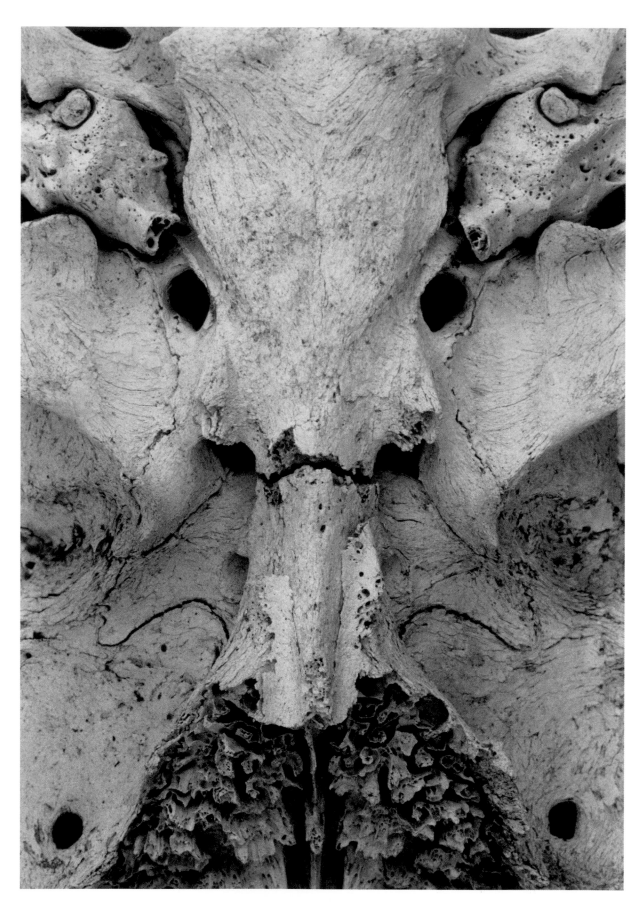

PLATE 49: Cow Skull, 2007

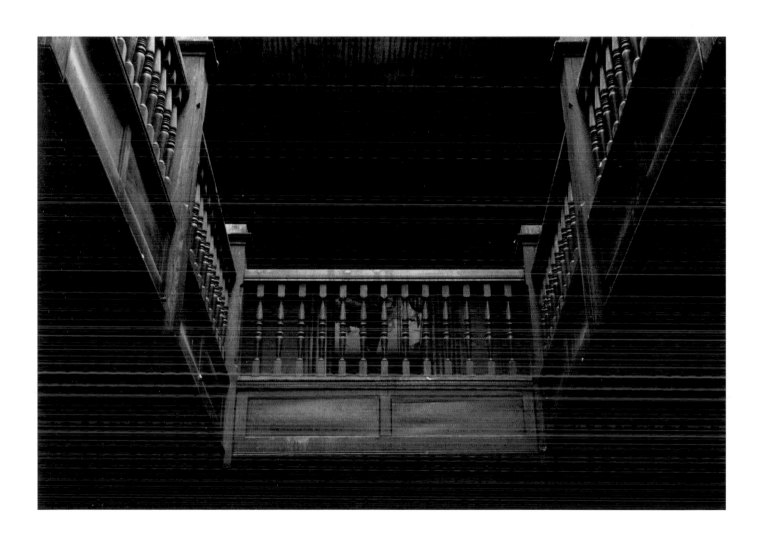

PLATE 50: Hotel, Second Floor, 2006

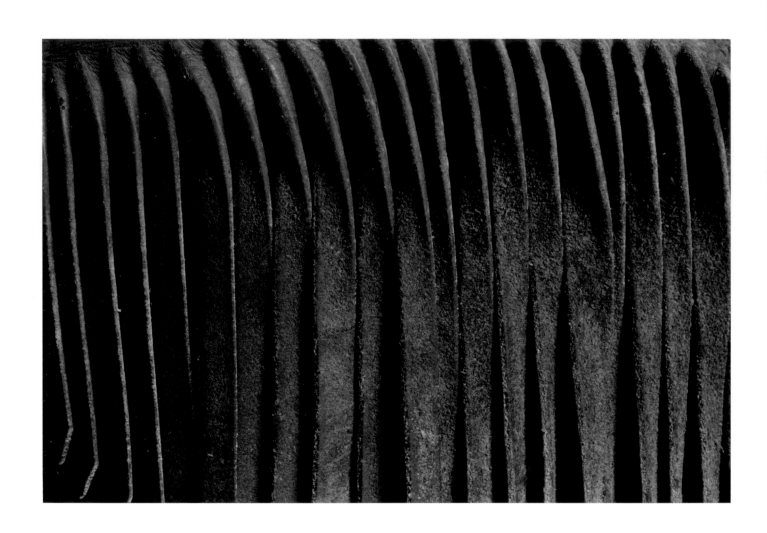

PLATE 51: Chap Fringe, 2007

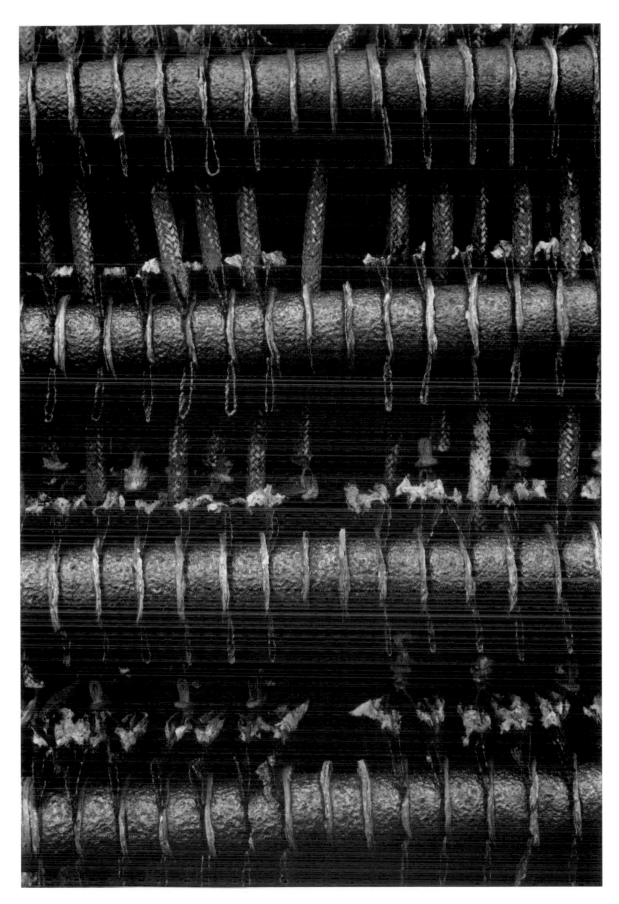

PLATE 52: Rheostat—Side View, 2006

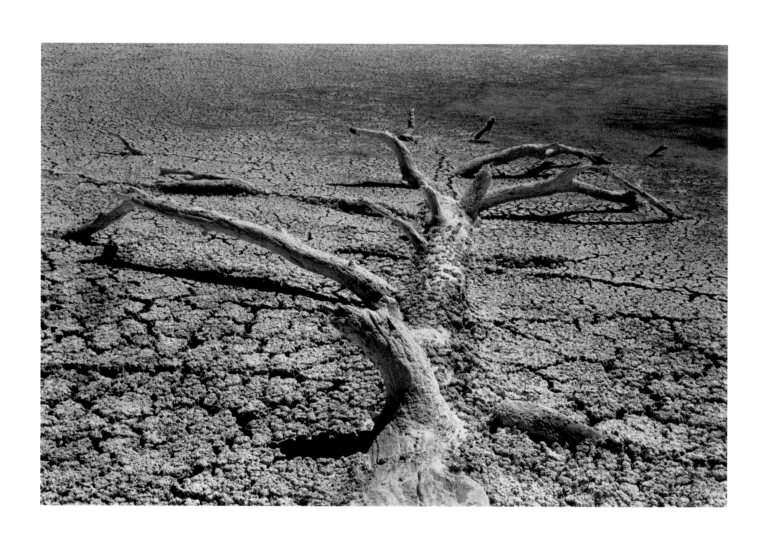

PLATE 53: Saline Seep No. 2, 2008

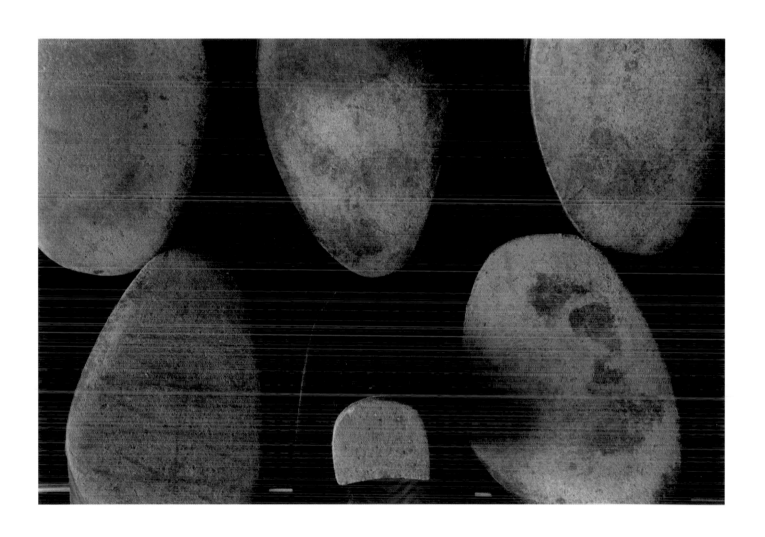

PLATE 54: Shoe Tree, 2007

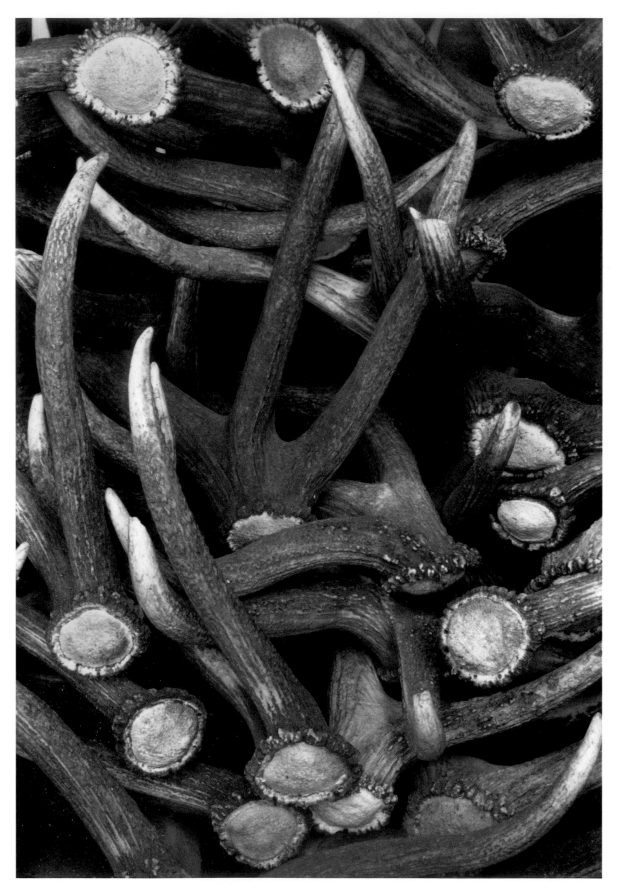

PLATE 55: Antlers, 2008

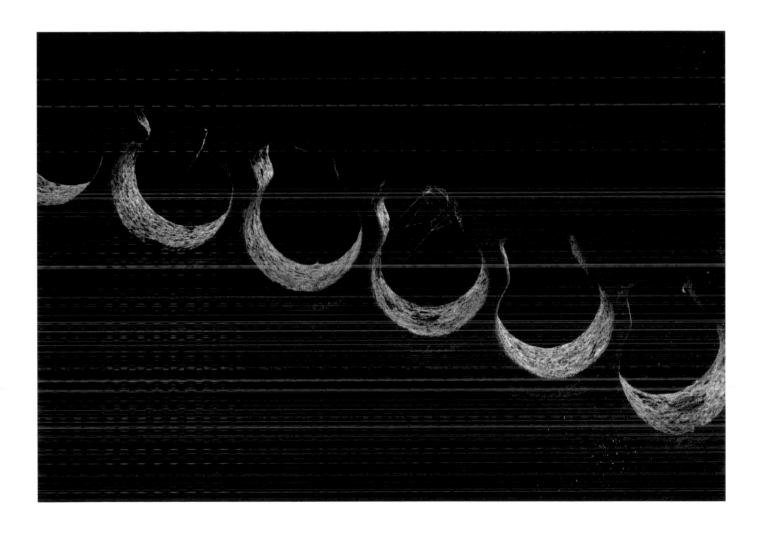

PLATE 56: Farm Tool, 2006

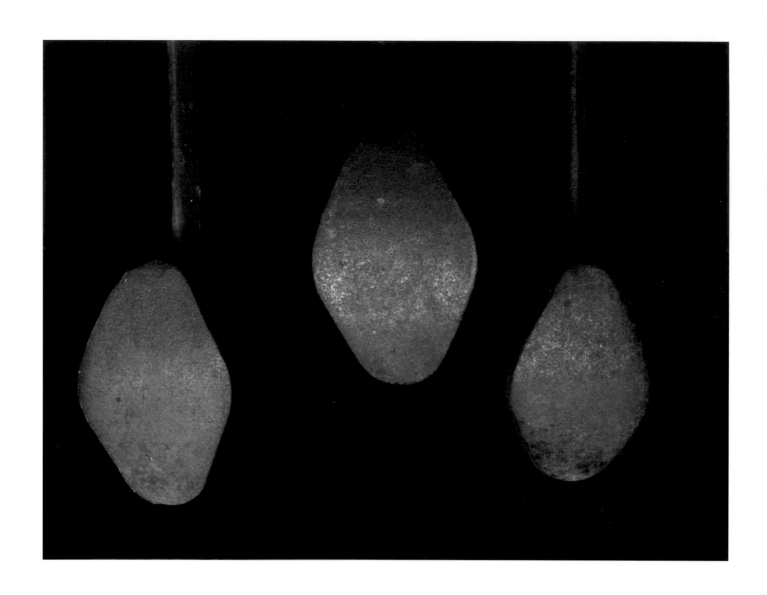

PLATE 57: Pedals, 2007

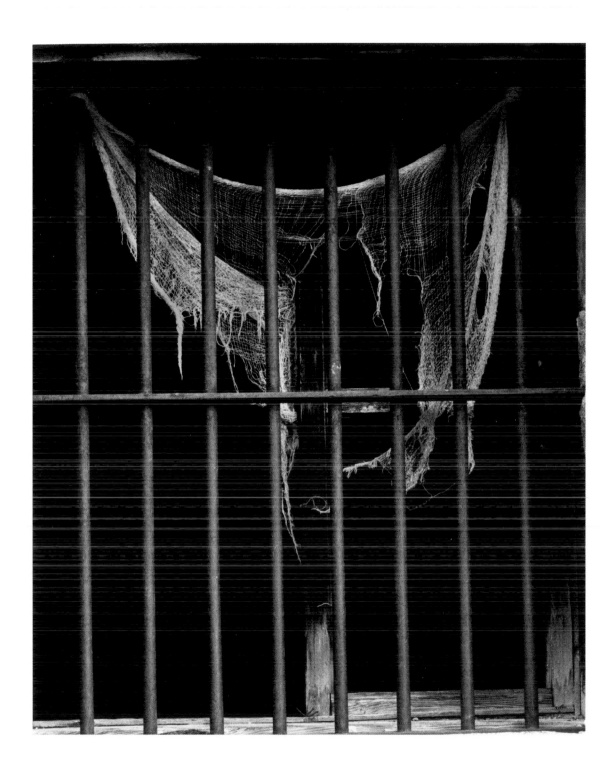

PLATE 58: Jail Curtains, 2010

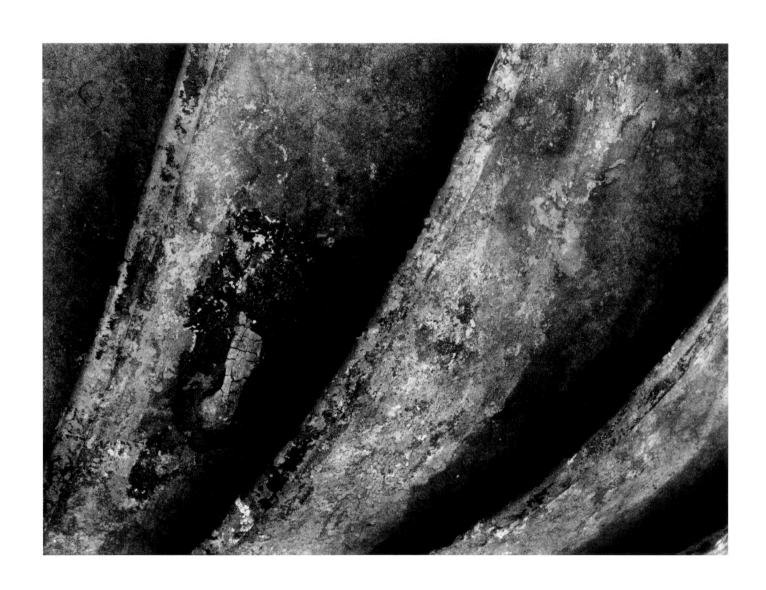

PLATE 59: Wind Vanes, 2010

VITA

Richard S. Buswell

SOLO EXHIBITIONS

2011	2012	*Treasured Montana Artist*, Montana State Capitol Building, Helena, Mont.
	2011	Housatonic Museum of Art, Bridgeport, Conn.
	2011	Appleton Museum of Art, Ocala, Fla.
	2011	South Dakota Art Museum, South Dakota State University, Brookings, S.Dak.
	2010	Holter Museum of Art, Helena, Mont.
2008–2009		Springfield Museum of Fine Arts, Springfield, Mass.
	2008	Gallery and Museum, University of Montana Western, Dillon, Mont.
	2008	Nora Eccles Harrison Museum of Art, Utah State University, Logan, Utah
	2007	Montana Museum of Art & Culture, University of Montana, Missoula, Mont.
	2006	Nora Eccles Harrison Museum of Art, Utah State University, Logan, Utah
	2006	Museum of the Rockies, Montana State University, Bozeman, Mont.
	2005	Prichard Art Gallery, University of Idaho, Moscow, Idaho
	2005	Booth Western Art Museum, Cartersville, Ga.
	2005	Holter Museum of Art, Helena, Mont.
	2004	International Photography Hall of Fame and Museum, Oklahoma City, Okla.
	2004	Western Heritage Center, Billings, Mont.
	2004	Gallery and Museum, University of Montana Western, Dillon, Mont.
2002–2003		Paris Gibson Square Museum of Art, Great Falls, Mont.
	2002	Montana Museum of Art & Culture, University of Montana, Missoula, Mont.
	2002	Northwest Art Center, Minot State University, Minot, N.Dak.
	2002	Medicine Hat Museum and Art Gallery, Medicine Hat, Alberta
	2001	Iris and B. Gerald Cantor Art Gallery, College of the Holy Cross, Worcester, Mass.
	2001	Braithwaite Fine Arts Gallery, Southern Utah University, Cedar City, Utah
	2001	Plains Art Museum, Fargo, N.Dak.
	2001	Hockaday Museum of Art, Kalispell, Mont.
	2000	MonDak Heritage Center, Sidney, Mont.
	2000	The Emerson at Beall Park Art Center, Bozeman, Mont.
	2000	Holter Museum of Art, Helena, Mont.
	1999	BICC Gallery, Oregon Health & Science University, Portland, Ore.
	1999	Frye Art Museum, Seattle, Wash.
	1999	Kimball Art Center, Park City, Utah
	1999	Arts Chateau, Butte, Mont.
	1999	Gallery and Museum, University of Montana Western, Dillon, Mont.
	1998	Center for Arts & History, Lewis-Clark State College, Lewiston, Idaho
	1998	Copper Village Museum and Arts Center, Anaconda, Mont.
	1997	John B. Davis Gallery, Department of Art, Idaho State University, Pocatello, Idaho
	1996	Department of Fine Arts, Carroll College, Helena, Mont.

1993 Western Heritage Center, Billings, Mont.

1993 Gallery and Museum, University of Montana Western, Dillon, Mont.

1992 Holter Museum of Art, Helena, Mont.

1992 Paxson Gallery, Museum of Fine Arts, University of Montana, Missoula, Mont.

SELECT GROUP EXHIBITIONS

2012 Valdosta National 2012 All-Media Juried Competition, Valdosta State University, Valdosta, Ga.

2012 33rd Annual Paper in Particular Exhibition, Columbia College, Columbia, Mo.

2012 Americas 2012: Paperworks Competition, Northwest Art Center, Minot State University, Minot, N.Dak.

2011 *About Architecture: Selections from the Permanent Collection*, Downtown Gallery, University of Tennessee, Knoxville School of Art, Knoxville, Tenn.

2011 2011 20" x 20" x 20": National Compact Competition and Exhibit, Union Art Gallery, Louisiana State University, Baton Rouge, La.

2011 24th September Competition Exhibition, Alexandria Museum of Art, Alexandria, La.

2011 Americas 2011: All Media Competition , National Juried Exhibition, Northwest Art Center, Minot State University, Minot, N.Dak.

2011 *Recent Acquisitions*, Appleton Museum of Art, Ocala, Fla.

2011 *Picturing Technology: Land and Machine*, Madison Museum of Contemporary Art, Madison, Wis.

2011 54th Chautauqua Annual Exhibition of Contemporary Art, Visual Arts at Chautauqua Institution, Chautauqua, N.Y.

2011 83rd Annual Juried Exhibition, Art Association of Harrisburg, Harrisburg, Pa.

2011 34th Annual Art on Paper Exhibition National Juried Exhibition, Maryland Federation of Art, Annapolis, Md.

2011 *Point of View: Photographs from the Permanent Collection*, High Museum of Art, Atlanta, Ga.

2011 7th Photographic Image Biennial Exhibition, Wellington B. Gray Gallery, East Carolina University, Greenville, N.C.

2011 26th Annual International Exhibition, Meadows Gallery, University of Texas at Tyler, Tyler, Tex.

2011 32nd Annual Paper in Particular Exhibition, Columbia College, Columbia, Mo.

2011 Americas 2011: Paperworks Competition, Northwest Art Center, Minot State University, Minot, N.Dak.

2010 *New Acquisitions, 2005–2010*, Muscarelle Museum of Art, College of William & Mary, Williamsburg, Va.

2010 2010 20" x 20" x 20": A National Compact Competition and Exhibit, Union Art Gallery, Louisiana State University, Baton Rouge, La.

2010 23rd September Competition Exhibition, Alexandria Museum of Art, Alexandria, La.

2010 Artful Photography Exhibition, Maryland Federation of Art, Annapolis, Md.

2010 53rd Chautauqua Annual Exhibition of Contemporary Art, Visual Arts at Chautauqua Institution, Chautauqua, N.Y.

2010 82nd Annual Juried Exhibition, Art Association of Harrisburg, Harrisburg, Pa.

2010 33rd Annual Art on Paper National Juried Exhibition, Maryland Federation of Art, Annapolis, Md.

2010 31st Annual Paper in Particular Exhibition, Columbia College, Columbia, Mo.

2010 Magic Silver 2010, Murray State University, Murray, Ky.

2010 Valdosta National 2010 All-Media Juried Competition, Valdosta State University, Valdosta, Ga.

2010 Americans 2010: Paperworks Competition, Northwest Art Center, Minot State University, Minot, N.Dak.

2009 *Recent Acquisitions: Art*, University Museum, Southern Illinois University, Carbondale, Ill.

2009 52nd Chautauqua Annual Exhibition of Contemporary Art, Visual Arts at Chautauqua Institution, Chautauqua, N.Y.

2009 *Home: A National, Juried Exhibition of Origins, Places and Connections*, Attleboro Arts Museum, Attleboro, Mass.

2009 2009 20" x 20" x 20": A National Compact Competition and Exhibit, Union Art Gallery, Louisiana State University, Baton Rouge, La.

2009 Montana Triennial, Missoula Art Museum, Missoula, Mont.

2009 81st Annual Juried Exhibition, Art Association of Harrisburg, Harrisburg, Pa.

2009 Valdosta National 2009 All-Media Juried Competition, Valdosta State University, Valdosta, Ga.

2009 30th Annual Paper in Particular Exhibition, Columbia College, Columbia, Mo.

2009 6th Photographic Image Biennial Exhibition, Wellington B. Gray Gallery, East Carolina University, Greenville, N.C.

2009 Americas 2009: Paperworks Competition, Northwest Art Center, Minot State University, Minot, N.Dak.

2008 21st September Competition Exhibition, Alexandria Museum of Art, Alexandria, La.

2008 51st Chautauqua Annual Exhibition of Contemporary Art, Visual Arts at Chautauqua Institution, Chautauqua, N.Y.

2008 *Art of the American West from the Permanent Collection*, Swope Art Museum, Terre Haute, Ind.

2008 80th Annual Juried Exhibition, Art Association of Harrisburg, Harrisburg, Pa.

2008 Valdosta National 2008 All-Media Juried Competition, Valdosta State University, Valdosta, Ga.

2008 Americas 2008: Paperworks Competition, Northwest Art Center, Minot State University, Minot, N.Dak.

2008 *Der Zeitgenosse*, Gallery of Art, Eastern Washington University, Cheney, Wash.

2008 30th Annual Art on Paper National Juried Exhibition, Maryland Federation of Art, Annapolis, Md.

2007 24th Annual National Juried Exhibition, Berkeley Art Center, Berkeley, Calif.

2007 2007 Holter Museum Art Auction, Holter Museum of Art, Helena, Mont.

2007 20th September Competition Exhibition, Alexandria Museum of Art, Alexandria, La.

2007 Americas 2000: All Media Competition, Northwest Art Center, Minot State University, Minot, N.Dak.

2007 50th Chautauqua Annual Exhibition of Contemporary Art, Visual Arts at Chautauqua Institution, Chautauqua, N.Y.

2007 9th Annual National Juried Small Works Exhibition, Attleboro Arts Museum, Attleboro, Mass.

2007 ANA 35, Holter Museum of Art, Helena, Mont.

2007 Current Work 2007, Fayetteville State University, Fayetteville, N.C.

2007 34th Annual Juried Competition, Masur Museum of Art, Monroe, La.

2007 30th Annual Art on Paper National Juried Exhibition, Maryland Federation of Art, Annapolis, Md.

2007 22nd Annual Positive/Negative National Juried Art Exhibition, Slocumb Galleries, East Tennessee State University, Johnson City, Tenn.

2007 *Recent Acquisitions from the Permanent Collection*, Birmingham Museum of Art, Birmingham, Ala.

2007 Artists Council 38th Annual National Juried Exhibition, Palm Springs Art Museum, Palm Springs, Calif.

2007 Valdosta National 2007 All-Media Juried Competition, Valdosta State University, Valdosta, Ga.

2006 *The Camera's Eye: Intriguing Images from the Permanent Collection*, Springfield Museum of Fine Arts, Springfield, Mass.

2006 *Selected Photographs from the Bluff Collection and the Telfair Museum of Art*, Telfair Museum of Art, Savannah, Ga.

2006 Art on the Plains 9: 9th Annual Regional Juried Exhibition, Plains Art Museum, Fargo, N.Dak.

2006 19th September Competition Exhibition, Alexandria Museum of Art, Alexandria, La.

2006 Americas 2000: All Media Competition, Northwest Art Center, Minot State University, Minot, N.Dak.

2006 49th Chautauqua Annual Exhibition of Contemporary Art, Visual Arts at Chautauqua Institution, Chautauqua, N.Y.

2006 8th Annual National Juried Small Works Exhibition, Attleboro Arts Museum, Attleboro, Mass.

2006 2006 Holter Museum Art Auction, Holter Museum of Art, Helena, Mont.

2006 Artists Council 37th Annual National Juried Exhibition, Palm Springs Art Museum, Palm Springs, Calif.

2006 29th Annual Art on Paper National Juried Exhibition, Maryland Federation of Art, Annapolis, Md.

2006 33rd Annual Juried Competition, Masur Museum of Art, Monroe, La.

2006 2006 20" x 20" x 20": A National Compact Competition and Exhibit, Union Art Gallery, Louisiana State University, Baton Rouge, La.

2006 2006 Harnett Biennial of American Prints, Joel and Lila Harnett Museum of Art, University of Richmond Museums, Richmond, Va.

2006 19th McNeese National Works on Paper, McNeese State University, Lake Charles, La.

2006 Toledo Friends of Photography 2006 National Juried Photographic Exhibition, Center for the Visual Arts Gallery, University of Toledo, Toledo, Ohio

2006 Valdosta National 2006 All-Media Juried Competition, Valdosta State University, Valdosta, Ga.

2005 *Black and White and Shades of Gray: Photography Without Color*, Herbert Johnson Museum of Art, Cornell University, Ithaca, N.Y.

2005 Art on the Plains 8: 8th Annual Regional Juried Exhibition, Plains Art Museum, Fargo, N.Dak.

2005 10th Annual National Art Exhibition, St. John's University, Queens, N.Y.

2005 18th September Competition Exhibition, Alexandria Museum of Art, Alexandria, La.

2005 Photo National 2005, Lancaster Museum of Art, Lancaster, Pa.

2005 Americas 2000: All Media Competition, Northwest Art Center, Minot State University, Minot, N.Dak.

2005 2005 Holter Museum Art Auction, Holter Museum of Art, Helena, Mont.

2005 77th Annual Juried Exhibition, Art Association of Harrisburg, Harrisburg, Pa.

2005 28th Annual Art on Paper National Juried Exhibition, Maryland Federation of Art, Annapolis, Md.

2005 32nd Annual Juried Competition, Masur Museum of Art, Monroe, La.

2005 *Recent Acquisitions to the Swope Collection*, Swope Art Museum, Terre Haute, Ind.

2005 20th Annual International Juried Show, Visual Arts Center of New Jersey Center, Summit, N.J.

2005 Fourth Photographic Image Biennial Exhibition, Wellington B. Gray Gallery, East Carolina University, Greenville, N.C.

2005 Americas 2000: Paperworks Competition, Northwest Art Center, Minot State University, Minot, N.Dak.

2005 Valdosta National 2005 All-Media Juried Competition, Valdosta State University, Valdosta, Ga.

2004 Winter Showcase Invitational, Holter Museum of Art, Helena, Mont.

2004 *The Permanent Collection: A Celebration of Recent Acquisitions, 2000–2004*, Jule Collins Smith Museum of Fine Art, Auburn University, Auburn, Ala.

2004 ANA 33, Holter Museum of Art, Helena, Mont.

2004 Art on the Plains 7: 7th Annual Regional Juried Exhibition, Plains Art Museum, Fargo, N.Dak.

2004 *Visual Proof!*, 9th Annual Photographic Competition Exhibition, Photographic Center Northwest, Seattle, Wash.

2004 2004 20" x 20" x 20": A National Compact Competition and Exhibit, Union Art Gallery, Louisiana State University, Baton Rouge, La.

2004 27th Annual Art on Paper National Juried Exhibition, Maryland Federation of Art, Annapolis, Md.

2004 Current Work 2004, Fayetteville State University, Fayetteville, N.C.

2004 17th McNeese National Works on Paper, McNeese State University, Lake Charles, La.

2004 *Northwest Biennial: Building Wise*, Tacoma Art Museum, Tacoma, Wash.

2004 6th American Print Biennial, Joel and Lila Harnett Museum of Art, University of Richmond Museums, Richmond, Va.

2004 Rocky Mountain Biennial 2004, Museum of Contemporary Art, Fort Collins, Colo.

2004 25th Annual Paper in Particular Exhibition, Columbia College, Columbia, Mo.

2004 Dishman Competition, Dishman Art Museum, Lamar University, Beaumont, Tex.

2004 Valdosta National 2004 All-Media Juried Competition, Valdosta State University, Valdosta, Ga.

2004 19th Annual International Juried Show, Visual Arts Center of New Jersey Center, Summit, N.J.

2003 Winter Showcase Invitational, Holter Museum of Art, Helena, Mont.

2003 Rosenthal International 2003, Fayetteville State University, Fayetteville, N.C.

2003 Art on the Plains 6: 6th Annual Regional Juried Exhibition, Plains Art Museum, Fargo, N.Dak.

2003 38th Annual Open National Exhibition, Fine Arts Institute of the San Bernardino County Museum, Redlands, Calif.

2003 *Expanding the Legacy: Kresge Art Museum Collects*, Kresge Art Museum, Michigan State University, East Lansing, Mich.

2003 ANA 32, Holter Museum of Art, Helena, Mont.

2003 *Visible Rhythm Exhibition*, San Jose Museum of Art, San Jose, Calif.

2003 26th Annual Art on Paper National Juried Exhibition, Maryland Federation of Art, Annapolis, Md.

2003 18th Annual International Exhibition, Meadows Gallery, University of Texas at Tyler, Tyler, Tex.

2003 13th Annual National Art Competition, Truman State University, Kirksville, Mo.

2003 Current Work 2003, Fayetteville State University, Fayetteville, N.C.

2003 Artists Council 34th Annual National Juried Exhibition, Palm Springs Art Museum, Palm Springs, Calif.

2003 18th Annual International Juried Show, Visual Arts Center of New Jersey, Summit, N.J.

2002 Winter Showcase Invitational, Holter Museum of Art, Helena, Mont.

2002 Art on the Plains 5: 5th Annual Regional Juried Exhibition, Plains Art Museum, Fargo, N.Dak.

2002 37th Annual Open National Exhibition, Fine Arts Institute of the San Bernardino County Museum, Redlands, Calif.

2002 New Art of the West 8, Eiteljorg Museum of American Indians and Western Art, Indianapolis, Ind.

2002 ANA 31, Holter Museum of Art, Helena, Mont.

2002 Photo National 2002, Lancaster Museum of Art, Lancaster, Pa.

2002 *Personal Viewpoints*, 7th Annual Photographic Competition Exhibition, Photographic Center Northwest, Seattle, Wash.

2002 *DeCordova Collects: Recent Acquisitions from the Permanent Collection*, DeCordova Museum and Sculpture Park, Lincoln, Mass.

2002 74th Annual Juried Exhibition, Art Association of Harrisburg, Harrisburg, Pa.

2002 7th Annual *In Focus* Juried Photography Exhibition, Center for Arts & History, Lewis-Clark State College, Lewiston, Idaho

2002 *Views and Visions: Montana Landscape Photography*, Museum of the Rockies, Montana State University, Bozeman, Mont.

2002 Works on Paper 2002: Recent Drawing, Prints, and Photographs, Union Art Gallery, Louisiana State University, Baton Rouge, La.

2002 17th Annual International Exhibition, Meadows Gallery, University of Texas at Tyler, Tyler, Tex.

2002 Dishman Competition, Dishman Art Gallery, Lamar University, Beaumont, Tex.

2002 5th American Print Biennial, Joel and Lila Harnett Museum of Art, University of Richmond Museums, Richmond, Va.

2002 17th Annual Positive/Negative National Juried Art Exhibition, Slocumb Galleries, East Tennessee State University, Johnson City, Tenn.

2002 Members Showcase 2002, Berkeley Art Center Association, Berkeley, Calif.

2002 23rd Annual Paper in Particular Exhibition, Columbia College, Columbia, Mo.

2001 11th Annual Center Awards, Center for Photographic Art, Carmel, Calif.

2001 *Light²: Images from the Photography Collections*, Alfred O. Kuhn Library Gallery, University of Maryland, Baltimore County, Baltimore, Md.

2001 Winter Showcase Invitational, Holter Museum of Art, Helena, Mont.

2001 36th Annual Open National Exhibition, Fine Arts Institute of the San Bernardino County Museum, Redlands, Calif.

2001 Art on the Plains 4: 4th Annual Regional Juried Exhibition, Plains Art Museum, Fargo, N.Dak.

2001 Art Equinox 2001: A Regional Survey of Contemporary Art, Paris Gibson Square Museum of Art, Great Falls, Mont.

2001 18th Annual National Juried Exhibition, Berkeley Art Center, Berkeley, Calif.

2001 *Beneath the Surface*, 6th Annual Photographic Competition Exhibition, Photographic Center Northwest, Seattle, Wash.

2001 18th Annual Lewis-Clark National Juried Exhibition, Center for Arts & History, Lewis-Clark State College, Lewiston, Idaho

2001 2001 National Juried Exhibition, Provincetown Art Association and Museum, Provincetown, Mass.

2001 73rd Annual Juried Exhibition, Art Association of Harrisburg, Harrisburg, Pa.

2001 6th Annual *In Focus* Juried Photography Exhibition, Center for Arts & History, Lewis-Clark State College, Lewiston, Idaho

2001 14th Annual ARTStravaganza, Hunter Museum of American Art, Chattanooga, Tenn.

2001 7th Annual National Art Exhibition, St. John's University, Queens, N.Y.

2001 16th Annual National Works on Paper, Meadows Gallery, University of Texas at Tyler, Tyler, Tex.

2001 Current Work 2001, Fayetteville State University, Fayetteville, N.C.

2001 16th Annual International Juried Show, Visual Arts Center of New Jersey, Summit, N.J.

2001 16th Annual Positive/Negative National Juried Art Exhibition, Slocumb Galleries, East Tennessee University, Johnson City, Tenn.

2001 22nd Annual Paper in Particular Exhibition, Columbia College, Columbia, Mo.

2000 35th Annual Open National Exhibition, Fine Arts Institute of the San Bernardino County Museum, Redlands, Calif.

2000 Winter Showcase Invitational, Holter Museum of Art, Helena, Mont.

2000 *American Identities: Land, People, Word, Body, Spirit*, Gibson Gallery, Art Museum at the State University of New York at Potsdam, Potsdam, N.Y.

2000 10th Annual Photography Exhibition, Maryland Federation of Art, Annapolis, Md.

2000 *Forty Freedoms Exhibition—A Northern Rockies Invitational*, Montana Museum of Art & Culture, University of Montana, Missoula, Mont.

2000 Art on the Plains 3: 3rd Annual Regional Juried Exhibition, Plains Art Museum, Fargo, N.Dak.

2000 CrossCurrents: Triennial National Juried Exhibition of Contemporary Art, Walter Anderson Museum of Art, Ocean Springs, Miss.

2000 17th Annual Lewis-Clark National Juried Art Exhibition, Center for Arts & History, Lewis-Clark State College, Lewiston, Idaho

2000 13th Annual ARTstravaganza, Hunter Museum of American Art, Chattanooga, Tenn.

2000 72nd Annual Juried Exhibition, Art Association of Harrisburg, Harrisburg, Pa.

2000 5th Annual *In Focus* Juried Photography Exhibition, Center for Arts & History, Lewis-Clark State College, Lewiston, Idaho

2000 23rd Annual Art on Paper National Juried Exhibition, Maryland Federation of Art, Annapolis, Md.

2000 15th Annual National Works on Paper, Meadows Gallery, University of Texas at Tyler, Tyler, Tex.

2000 *New Photography in the Collection*, Art Museum of Missoula, Missoula, Mont.

2000 12th Annual National Juried Competition, Truman State University, Kirksville, Mo.

2000 21st Annual Paper in Particular Exhibition, Columbia College, Columbia, Mo.

2000 Americas 2000: Paperworks Competition, Minot State University, Minot, N.Dak.

1999–2000 Winter Showcase Invitational, Holter Museum of Art, Helena, Mont.

1999 National Juried Exhibition, Union Art Gallery, Louisiana State University, Baton Rouge, La.

1999 12th Annual ARTstravaganza, Hunter Museum of American Art, Chattanooga, Tenn.

1999 17th Annual National Juried Exhibition, Alexandria Museum of Art, Alexandria, La.

1999 16th Annual Lewis-Clark National Juried Art Exhibition, Center for Arts & History, Lewis-Clark State College, Lewiston, Idaho

1999 Art Equinox 1999: A Regional Survey of Contemporary Art, Paris Gibson Square Museum of Art, Great Falls, Mont.

1999 1999 National Works on Paper, St. John's University, Queens, N.Y.

1999 71st Annual Juried Exhibition, Art Association of Harrisburg, Harrisburg, Pa.

1999 4th Annual *In Focus* Juried Photography Exhibition, Center for Arts & History, Lewis-Clark State College, Lewiston, Idaho

1999 Canyon Country Fine Art Competition, Braithwaite Fine Arts Gallery, Southern Utah University, Cedar City, Utah

1999 Dishman Competition, Dishman Art Gallery, Lamar University, Beaumont, Tex.

1999 Artists Council 30th Annual National Juried Exhibition, Palm Springs Art Museum, Palm Springs, Calif.

1999 Greater Midwest International Exhibition XIV, Central Missouri State University, Warrensburg, Mo.

1999 20th Annual Paper in Particular Exhibition, Columbia College, Columbia, Mo.

1999 14th Annual Positive/Negative National Juried Art Exhibition, Slocumb Galleries, East Tennessee State University, Johnson City, Tenn.

1998–1999 *A Fine and Private Place: Mortality, Monuments and Memories*, Denver Art Museum, Denver, Colo.

1998–1999 *Collections: Recent Northwest Acquisitions*, Tacoma Art Museum, Tacoma, Wash.

1998–1999 Annual Exhibition and Auction, Art Museum of Missoula, Missoula, Mont.

1998–1999 Winter Showcase Invitational, Holter Museum of Art, Helena, Mont.

1998–1999 *The Paving of Paradise: A Century of Photographs of the Western Landscape*, Seattle Art Museum, Seattle, Wash.

1998 33rd Annual Open National Exhibition, Fine Arts Institute of the San Bernardino County Museum, Redlands, Calif.

1998 4th Annual Photographic Competition Exhibition, Photographic Center Northwest, Seattle, Wash.

1998 Dias de Los Muertos Festival, Hockaday Museum of Art, Kalispell, Mont.

1998 16th Annual National Juried Exhibition, Alexandria Museum of Art, Alexandria, La.

1998 15th Annual Lewis-Clark National Juried Art Exhibition, Center for Arts & History, Lewis-Clark State College, Lewiston, Idaho

1998 3rd Annual *In Focus* Juried Photography Exhibition, Center for Arts & History, Lewis-Clark State College, Lewiston, Idaho

1998 11th Annual ARTStravaganza, Hunter Museum of American Art, Chattanooga, Tenn.

1998 1998 National Juried Exhibition, Provincetown Art Association and Museum, Provincetown, Mass.

1998 Montana Interpretations Juried Art Exhibit, Montana Institute of Arts, Butte, Mont.

1998 Artists Council 29th Annual National Juried Exhibition, Palm Springs Art Museum, Palm Springs, Calif.

1998 4th Annual National Art Exhibition, St. John's University, Queens, N.Y.

1998 19th Annual Paper in Particular Exhibition, Columbia College, Columbia, Mo.

1997 Winter Showcase Invitational, Holter Museum of Art, Helena, Mont.

1997 32nd Annual Open National Exhibition, Fine Arts Institute of the San Bernardino County Museum, Redlands, Calif.

1997 ANA 26, Holter Museum of Art, Helena, Mont.

1997 Americas 2000: All Media Competition, Northwest Art Center, Minot State University, Minot, N.Dak.

1997 *Montana, Myths and Reality*, Sutton West Gallery, Center for the Rocky Mountain West, University of Montana, Missoula, Mont.

1997 2nd Annual *In Focus* Juried Photography Exhibition, Center for Arts & History, Lewis-Clark State College, Lewiston, Idaho

1997 Cross Currents Exhibition, Holter Museum of Art, Helena, Mont.

1997 69th Annual Juried Exhibition, Art Association of Harrisburg, Harrisburg, Pa.

1997 14th Annual Lewis-Clark National Juried Art Exhibition, Center for Arts & History, Lewis-Clark State College, Lewiston, Idaho

1997 Dishman Competition, Dishman Art Gallery, Lamar University, Beaumont, Tex.

1997 *Where Do We Live? Images of House and Home from the Permanent Collection*, Art Museum of Missoula, Missoula, Mont.

1997 12th Annual Positive/Negative National Juried Art Exhibition, Slocumb Galleries, East Tennessee State University, Johnson City, Tenn.

1996 Winter Showcase Invitational, Holter Museum of Art, Helena, Mont.

1996 31st Annual Open National Exhibition, Fine Arts Institute of the San Bernardino County Museum, Redlands, Calif.

1996 Kaleidoscope 1996, Department of Fine Arts, Carroll College, Helena, Mont.

1996 Magnum Opus IX, Sacramento Fine Arts Center, Carmichael, Calif.

1996 ANA 25, Holter Museum of Art, Helena, Mont.

1996 68th Annual Juried Exhibition, Art Association of Harrisburg, Harrisburg, Pa.

1996 *Jail Exposures*, Myrna Loy Center, Helena, Mont.

1996 Artists Council 27th Annual National Juried Exhibition, Palm Springs Art Museum, Palm Springs, Calif.

1996 Dishman Competition, Dishman Art Gallery, Lamar University, Beaumont, Tex.

1995 Winter Showcase Invitational, Holter Museum of Art, Helena, Mont.

1995 Kaleidoscope 1995, Department of Fine Arts, Carroll College, Helena, Mont.

1995 Annual Exhibition and Auction, Art Museum of Missoula, Missoula, Mont.

1995 ANA 24, Holter Museum of Art, Helena, Mont.

1995 Chautauqua Art Association Galleries, Chautauqua, N.Y.

1995 Texas National '95, College of Fine Arts, Stephen F. Austin State University, Nacogdoches, Tex.

1995 Artists Council 26th Annual National Juried Exhibition, Palm Springs Art Museum, Palm Springs, Calif.

1995 North Dakota National Juried Exhibition, Minot Art Gallery, Minot, N.Dak.

1995 *Photographing the American West*, Paris Gibson Square Museum of Art, Great Falls, Mont.

1994 Annual Exhibition and Auction, Missoula Museum of the Arts, Missoula, Mont.

1994 Montana Governor's Mansion, Governor's Culture Foundation, Helena, Mont.

1994 *Montana Artists*, Idaho Falls Art Council Gallery, Idaho Falls, Idaho

1994 Pacific Northwest Annual Regional Juried Exhibition, Bellevue Art Museum, Bellevue, Wash.

1994 *Mini Treasures: Art of the West*, Holter Museum of Art, Helena, Mont.

1990–1992 *Montana Reflections: Contemporary Photographs—Historic Visions*, Museum of the Montana State Historical Society, Helena, Mont.

PERMANENT COLLECTIONS, PUBLIC

International

National Photography Collection, National Media Museum, Bradford, England
Scottish National Photography Collection, National Galleries of Scotland, Edinburgh, Scotland
Bibliotheque Nationale de France, Paris, France
Art Gallery of Hamilton, Hamilton, Ontario
Glenbow Museum, Calgary, Alberta
Winnipeg Art Gallery, Winnipeg, Manitoba
Art Gallery of Nova Scotia, Halifax, Nova Scotia

American

Smithsonian American Art Museum, Washington, D.C.
Museum of Fine Arts, Boston, Boston, Mass.
Corcoran Gallery of Art, Washington, D.C.
Museum of Fine Arts, Houston, Houston, Tex.
George Eastman House International Museum of Photography and Film, Rochester, N.Y.
Detroit Institute of Arts, Detroit, Mich.

Denver Art Museum, Denver, Colo.

Seattle Art Museum, Seattle, Wash.

Baltimore Museum of Art, Baltimore, Md.

Brooklyn Museum of Art, Brooklyn, N.Y.

Photographic History Collection, Smithsonian National Museum of American History, Washington, D.C.

Prints and Photographs Division, Library of Congress, Washington, D.C.

Fogg Art Museum, Harvard University Art Museums, Cambridge, Mass.

Yale University Art Gallery, New Haven, Conn.

Yale Collection of Western Americana, Beinecke Library, Yale University, New Haven, Conn.

Nelson-Atkins Museum of Art, Kansas City, Mo.

High Museum of Art, Atlanta, Ga.

Birmingham Museum of Art, Birmingham, Ala.

New Orleans Museum of Art, New Orleans, La.

Worcester Art Museum, Worcester, Mass.

Dallas Museum of Art, Dallas, Tex.

Bancroft Library, University of California, Berkeley, Berkeley, Calif.

Chrysler Museum of Art, Norfolk, Va.

Indianapolis Museum of Art, Indianapolis, Ind.

Portland Art Museum, Portland, Ore.

Cincinnati Art Museum, Cincinnati, Ohio

Columbus Museum of Art, Columbus, Ohio

Hood Museum of Art, Dartmouth College, Hanover, N.H.

Archive of Documentary Arts, Rare Book, Manuscript and Special Collections Library, Duke University, Durham, N.C.

Everson Museum of Art, Syracuse, N.Y.

Oklahoma City Museum of Art, Oklahoma City, Okla.

University of Virginia Art Museum, Charlottesville, Va.

David Winton Bell Gallery, Brown University, Providence, R.I.

Museum of the American West, Autry National Center, Los Angeles, Calif.

Eiteljorg Museum of American Indians and Western Art, Indianapolis, Ind.

National Cowboy and Western Heritage Museum, Oklahoma City, Okla.

Crocker Art Museum, Sacramento, Calif.

Tacoma Art Museum, Tacoma, Wash.

Museum of Art, Rhode Island School of Design, Providence, R.I.

Berkeley Art Museum and Pacific Film Archive, University of California, Berkeley, Berkeley, Calif.

Huntington Library, Art Collections and Botanical Gardens, San Marino, Calif.

Department of Prints, Drawings and Photographs, New York Public Library, New York, N.Y.

Smith College Museum of Art, Northampton, Mass.

Herbert F. Johnson Museum of Art, Cornell University, Ithaca, N.Y.

Sheldon Memorial Art Gallery and Sculpture Garden, University of Nebraska–Lincoln, Lincoln, Neb.

Mississippi Museum of Art, Jackson, Miss.

Harn Museum of Art, University of Florida, Gainesville, Fla.

John and Mable Ringling Museum of Art, Florida State University, Sarasota, Fla.

Indiana University Art Museum, Bloomington, Ind.

Delaware Art Museum, Wilmington, Del.

Louisiana State University Museum of Art, Baton Rouge, La.

Flint Institute of Arts, Flint, Mich.

Heard Museum, Phoenix, Ariz.

Honolulu Academy of Arts, Honolulu, Hawaii

Arkansas Arts Center, Little Rock, Ark.

Telfair Museum of Art, Savannah, Ga.

Orlando Museum of Art, Orlando, Fla.

El Paso Museum of Art, El Paso, Tex.

Memphis Brooks Museum of Art, Memphis, Tenn.

Mobile Museum of Art, Mobile, Ala.

Dayton Art Institute, Dayton, Ohio

Tampa Museum of Art, Tampa, Fla.

Butler Institute of American Art, Youngstown, Ohio

Grunwald Center for the Graphic Arts, Armand Hammer Museum of Art and Cultural Center, University
 of California, Los Angeles, Los Angeles, Calif.

Harry Ransom Center, University of Texas, Austin, Tex.

Vero Beach Museum of Art, Vero Beach, Fla.

Museum of Photographic Arts, San Diego, Calif.

Madison Museum of Contemporary Art, Madison, Wis.

Heckscher Museum of Art, Huntingon, N.Y.

Mint Museum of Art, Charlotte, N.C.

Columbia Museum of Art, Columbia, S.C.

Museum of Fine Arts, St. Petersburg, Fla.

Portland Museum of Art, Portland, Maine

Allen Memorial Art Museum, Oberlin College, Oberlin, Ohio

Nevada Museum of Art, Reno, Nev.

Swope Art Museum, Terre Haute, Ind.

Utah Museum of Fine Arts, University of Utah, Salt Lake City, Utah

Appleton Museum of Art, Ocala, Fla.

Long Beach Museum of Art, Long Beach, Calif.

Boca Raton Museum of Art, Boca Raton, Fla.

University of Michigan Museum of Art, Ann Arbor, Mich.

Krannert Art Museum and Kinkead Pavillion, University of Illinois at Urbana–Champaign, Champaign, Ill.

Georgia Museum of Art, University of Georgia, Athens, Ga.

Chazen Museum of Art, University of Wisconsin–Madison, Madison, Wis.

Muscarelle Museum of Art, College of William & Mary, Williamsburg, Va.

San Jose Museum of Art, San Jose, Calif.

Patricia and Phillip Frost Art Museum, Florida International University, Miami, Fla.

Grand Rapids Art Museum, Grand Rapids, Mich.

Fort Wayne Museum of Art, Fort Wayne, Ind.

Rockford Art Museum, Rockford, Ill.

Kalamazoo Institute of Arts, Kalamazoo, Mich.

Bowdoin College Museum of Art, Brunswick, Maine

Fresno Art Museum, Fresno, Calif.

Contemporary Art Museum, University of South Florida, Tampa, Fla.

Fred Jones Jr. Museum of Art, University of Oklahoma, Norman, Okla.

Special Collections, Alfred O. Kuhn Library, University of Maryland, Baltimore County, Baltimore, Md.

McMullen Museum of Art, Boston College, Chestnut Hill, Mass.

Colorado Springs Fine Arts Center, Colorado Springs, Colo.

Monterey Museum of Art, Monterey, Calif.

Rockwell Museum of Western Art, Corning, N.Y.

Springfield Art Museum, Springfield, Mo.

Palm Springs Art Museum, Palm Springs, Calif.

Snite Museum of Art, University of Notre Dame, Notre Dame, Ind.

International Photography Hall of Fame and Museum, Oklahoma City, Okla.

Hunter Museum of American Art, Chattanooga, Tenn.

Taubman Museum of Art, Roanoke, Va.

Great Plains Art Museum, Center for Great Plains Studies, University of Nebraska–Lincoln, Lincoln, Neb.

Museum of New Mexico, Santa Fe, N.Mex.

San Antonio Museum of Art, San Antonio, Tex.

Montclair Art Museum, Montclair, N.J.

Davison Art Center, Wesleyan University, Middletown, Conn.

Springfield Museum of Fine Arts, Springfield, Mass.

Palmer Museum of Art, Pennsylvania State University, University Park, Pa.

Frederick R. Weisman Art Museum, University of Minnesota, Minneapolis, Minn.

Mead Art Museum, Amherst College, Amherst, Mass.

Mary and Leigh Block Museum of Art, Northwestern University, Evanston, Ill.

Spencer Museum of Art, University of Kansas, Lawrence, Kans.

Mount Holyoke College Museum of Art, South Hadley, Mass.

Western History Collection, Denver Public Library, Denver, Colo.

Museum of Art, Brigham Young University, Provo, Utah

Danforth Museum of Art, Framingham, Mass.

Jane Voorhees Zimmerli Art Museum, Rutgers, the State University of New Jersey, New Brunswick, N.J.

Lowe Art Museum, University of Miami, Coral Gables, Fla.

Syracuse University Art Galleries, Syracuse, N.Y.

Colby College Museum of Art, Waterville, Maine

Amarillo Museum of Art, Amarillo, Tex.

Springfield Museum of Art, Springfield, Ohio

New Britain Museum of American Art, New Britain, Conn.

William Benton Museum of Art, University of Connecticut, Storrs, Conn.

Washington State University Museum of Art, Pullman, Wash.

Kresge Art Museum, Michigan State University, East Lansing, Mich.

Muskegon Museum of Art, Muskegon, Mich.

Roswell Museum and Art Center, Roswell, N.Mex.

Fitchburg Art Museum, Fitchburg, Mass.

University Art Museum, State University of New York at Albany, Albany, N.Y.

University Art Museum, California State University, Long Beach, Long Beach, Calif.

Hilliard University Art Museum, University of Louisiana at Lafayette, Lafayette, La.

Hofstra Museum, Hofstra University, Hempstead, N.Y.

Bates College Museum of Art, Lewiston, Maine

Robert Hull Fleming Museum, University of Vermont, Burlington, Vt.

Lyman Allyn Art Museum, New London, Conn.

Ewing Gallery of Art and Architecture, University of Tennessee, Knoxville, Tenn.

Columbus Museum, Columbus, Ga.

Saginaw Art Museum, Saginaw, Mich.

Booth Western Art Museum, Cartersville, Ga.

Center for Photography at Woodstock, Woodstock, N.Y.

Racine Art Museum, Racine, Wis.

Museum of Northwest Art, La Conner, Wash.

Erie Art Museum, Erie, Pa.

Alexandria Museum of Art, Alexandria, La.

Northwest Museum of Arts and Culture, Spokane, Wash.

Buffalo Bill Historical Center, Cody, Wyo.

University of Kentucky Art Museum, Lexington, Ky.

Jule Collins Smith Museum of Fine Art, Auburn University, Auburn, Ala.

Cameron Art Museum, Wilmington, N.C.

Polk Museum of Art, Lakeland, Fla.

University Museum, Southern Illinois University, Carbondale, Ill.

C. M. Russell Museum, Great Falls, Mont.

Beach Museum of Art, Kansas State University, Manhattan, Kans.

Whatcom Museum of History and Art, Bellingham, Wash.

Nora Eccles Harrison Museum of Art, Utah State University, Logan, Utah

Gregg Museum of Art and Design, North Carolina State University, Raleigh, N.C.

University Art Museum, Colorado State University, Ft. Collins, Colo.

Harwood Museum of Art, University of New Mexico–Taos, Taos, N.Mex.

Ulrich Museum of Art, Wichita State University, Wichita, Kans.

Ogunquit Museum of American Art, Ogunquit, Maine

Hallie Ford Museum of Art, Willamette University, Salem, Ore.

Mills College Museum of Art, Oakland, Calif.

Richard S. Nelson Gallery and Fine Arts Collection, University of California, Davis, Davis, Calif.

Albrecht Kemper Museum of Art, Saint Joseph, Mo.

Kennedy Museum of Art, Ohio University, Athens, Ohio

Tweed Museum of Art, University of Minnesota Duluth, Duluth, Minn.

University of Maine Museum of Art, Bangor, Maine

Ruth Chandler Williamson Gallery, Scripps College, Claremont, Calif.

Brevard Art Museum, Melbourne, Fla.

South Dakota Art Museum, South Dakota State University, Brookings, S.Dak.

Hearst Art Gallery, St. Mary's College of California, Moraga, Calif.

Brauer Museum of Art, Valparaiso University, Valparaiso, Ind.

Decordova Museum and Sculpture Park, Lincoln, Mass.

Midwest Museum of American Art, Elkhart, Ind.

Iris and B. Gerald Cantor Art Gallery, College of the Holy Cross, Worcester, Mass.

Joel and Lila Harnett Print Study Center, University of Richmond Museums, Richmond, Va.

Housatonic Museum of Art, Bridgeport, Conn.

Philip Muriel Berman Museum of Art, Ursinus College, Collegeville, Pa.

University Art Museum, University of New Hampshire, Durham, N.H.

Masur Museum of Art, Monroe, La.

Lamar Dodd Art Center, LaGrange College, LaGrange, Ga.

Southern Alleghenies Museum of Art, Loretto, Pa.

Yellowstone Art Museum, Billings, Mont.

Montana Museum of Art & Culture, University of Montana, Missoula, Mont.

Jundt Art Museum, Gonzaga University, Spokane, Wash.

Washington County Museum of Fine Arts, Hagerstown, Md.

Nicolaysen Art Museum and Discovery Center, Casper, Wyo.

Plains Art Museum, Fargo, N.Dak.

Art Museum of Missoula, Missoula, Mont.

Northwest Art Center, Minot State University, Minot, N.Dak.

Paris Gibson Square Museum of Art, Great Falls, Mont.

Lancaster Museum of Art, Lancaster, Pa.

Holter Museum of Art, Helena, Mont.

Museum of the Montana State Historical Society, Helena, Mont.

Fine Arts Institute of the San Bernardino County Museum, Redlands, Calif.

Myrna Loy Center, Helena, Mont.

MAJOR PUBLICATIONS

2007 *Traces: Montana's Frontier Revisited*. Missoula: University of Montana Press and the Montana Museum of Art and Culture, University of Montana.

2004 "Richard Buswell," by Richard Newby. *Black and White Magazine*, no. 31 (June):100–103.

2002 *Silent Frontier: Icons of Montana's Early Settlement*. Missoula: Montana Museum of Art and Culture, University of Montana.

1997 *Echoes: A Visual Reflection*, rev. ed. Missoula: Archival Press, in association with the Museum of Fine Arts, University of Montana.

1992 *Echoes: A Visual Reflection*. Missoula: University of Montana School of Fine Arts. Exhibition catalog. Catalog received first place award for the *In Plant* International Conference Competition In Print '93.